BARROW-IN-FURNESS & DISTRICT

A POTTED HISTORY

GILL JEPSON

AMBERLEY

First published 2025

Amberley Publishing
The Hill, Stroud
Gloucestershire, GL5 4EP

www.amberley-books.com

Copyright © Gill Jepson, 2025

The right of Gill Jepson to be identified as the Author
of this work has been asserted in accordance with the
Copyrights, Designs and Patents Act 1988.

ISBN 978 1 3981 1674 0 (print)
ISBN 978 1 3981 1675 7 (ebook)

British Library Cataloguing in Publication Data.
A catalogue record for this book is available from the
British Library.

Typesetting by SJmagic DESIGN SERVICES, India.
Printed in Great Britain.

Contents

Introduction

This book has been a labour of love; it's something I have wanted to do for a long time. Furness is a wonderful and inspirational place which is often misunderstood and underestimated. It is geographically distanced from the mainstream but not too isolated not to have taken part in the national historical profile.

From its earliest days it has been significant, and remains of early settlers are being discovered regularly. The gaps in the historical record are being filled and the story completed. Those who insist we are 'out on a limb' do not understand the unique nature of the area and the people. They are resilient, innovative, and creative and have produced numerous great thinkers, artists, industrialists, and creators.

It is impossible to mention and record everything, but I have done my best to include the most interesting and unusual events, places, and people. I hope I have done it justice and have produced an informative and enjoyable potted history to extend knowledge and appreciation of the wonderful, beautiful place that is Furness.

Gill Jepson, 2023

Ancient Furness

Furness is a name derived from *futh* or *for* in old Norse, meaning rump or remnant in this case, and *ness* meaning headland. It refers to the geography reflecting the position of Walney Island and the mainland. The peninsula is surrounded by Morecambe Bay, the Irish Sea and Duddon Estuary. It has its own micro-climate and some unique habitats, creating a special landscape of great beauty. Glacial deposits and rock formations provide a rich variety of geology in the area. The Silurian deposits (approximately 350 million years old) consist of hardened mudstones and sandstone, some of which are slat – for example in Kirkby-Ireleth.

Carboniferous limestone rocks appeared at 250 million years, ranging from Askam to Ulverston and along a line from Dalton to Roose, Gleaston and then emerging at the coast. A good example of the limestone pavement is at Birkrigg between Bardsea and Ulverston.

Triassic sandstones from 150 million years ago make the common bedrock of the Barrow peninsula and is visible at Furness Abbey and Ormsgill quarries. There is an abundance of boulder clay and sand hills around the Walney and Sandscale Haws coastline, dumped by the melting glaciers. Evidence for glacial deposits can be seen across the lowland of Furness; one example of a huge boulder brought down from the hills is at James Dunn Park, Vickerstown, now a feature at the front of the park.

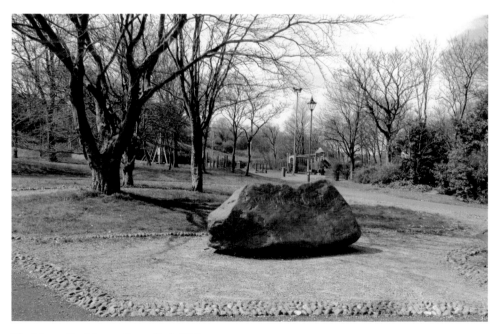

Glacial erratic at James Dunn Park, Walney.

The area has rich deposits of iron ore and was the catalyst for later industrialisation. Mines were sunk at Lindal, Askam, Dalton, Stainton, Stank and Yarlside, producing some of the purest iron ore.

The peninsula is surrounded by numerous islands, the largest being Walney. Barrow Island was originally separate from the hamlet of old Barrow or Barr-ai seated between Walney and Barrowhead. Piel and Roa Island were large enough to be inhabited, while Foulney is principally grass and shingle and its name arises from the many sea birds who nest and live there. Sheep Island is much smaller and was used as grazing by Furness Abbey and later for an isolation hospital. Both Foulney and Sheep Island are accessible on foot at low tide, as is Piel. Two smaller islets, Headin Haw and Dova Haw (Crab Island), are small tidal islands just off the coast of Barrow. Mud flats, sand dunes, salt marsh and tidal beaches provide a rich and varied habitat for sea birds, fish and crustaceans which is an area of high scientific importance.

Contrary to speculation, Barrow and district has growing evidence of early settlement. The remains seem sparse but nevertheless give us a good picture of emerging populations from prehistory. The lack of physical evidence was partly due to the limited archaeological excavations in the area and the durability of the early wooden structures. However, in

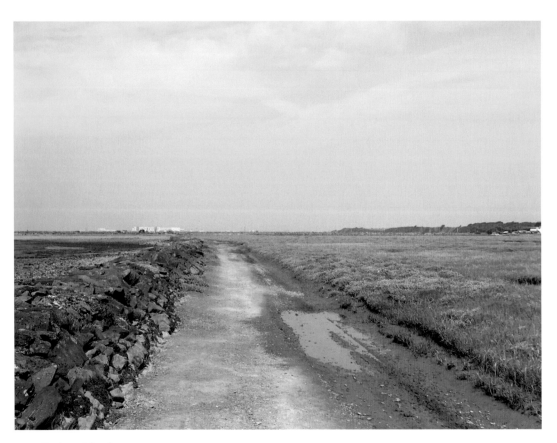

Foulney Island causeway.

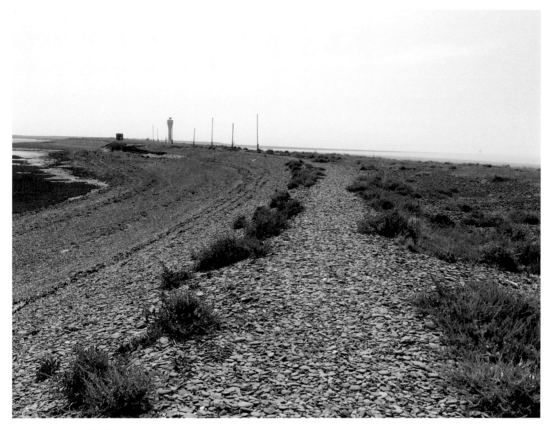

Foulney Island nature reserve.

recent decades there have been some amazing finds which help to build up the picture of early settlements in the area.

A range of both amateur and professional archaeologists have attempted to piece together the fragments of early history in the area. Some of the early interpretations might well be supposition but they highlight anomalies which could indicate habitation but lacked the archaeological evidence to back them up. One example is 'Black Castle', a hill in Barrow, better known as cenotaph hill in Barrow Park. Its name is recorded on old maps and allegedly Bronze Age artefacts have been found there. Little more is known, and it is impossible to validate this without further excavations.

Another mound is found at Eller Barrow, Pennington. It was thought to be a barrow but is irregular in shape and form. There are several tumuli marked on old maps in Furness, some of which are significant and easily seen, but many have been ploughed out or cleared. The mound in this case could be spoil from the railway rather than anything ancient but it does appear in records from 1805 prior to the advent of the railway. The mound might have changed over the years with subsequent dispersal or addition of material, but this is supposition presently.

Black Castle, now known as Cenotaph Hill.

Eller Barrow, Pennington.

However, across the district more tangible discoveries have been found. Bronze artefacts were found at Butt's Beck in Dalton, held within a burial cist in the 1870s. Urswick proves to be an interesting place with walls and earthworks, a burial chamber, and links to Birkrigg stone circle. The circle has two rings, the inner one comprised of ten stones and the outer ring having fifteen. The circle is divided by a ditch on one side and a bank. Previous studies revealed a layer of cobble stones and three cremation pits; two others were found, one beneath an urn and the other on cobbles. The circle is often called a druid circle, but pre-dates that period. More likely it's a Bronze Age feature, probably for ceremonial purposes. The outer ring has been disturbed and restored and faces the sea on the sloping hill dropping towards Sea Wood.

Earlier finds have appeared across the district, with Neolithic sites discovered on Walney. Dr G. Jackson carried out excavations at Biggar for several years, but much of that work remains unpublished. In Appley's (2013) PhD thesis he investigated the prehistoric environment of the Furness peninsula. This provided an environmental background to prehistoric activity and recorded changes in sea levels. It appears that during the Late Mesolithic and Early Neolithic periods Furness peninsula and Walney Island were either visited (by nomadic people) or settled. Evidence points to activities such as using the local volcanic materials and trading in stone tools. This tallies with excavations at Gleaston and

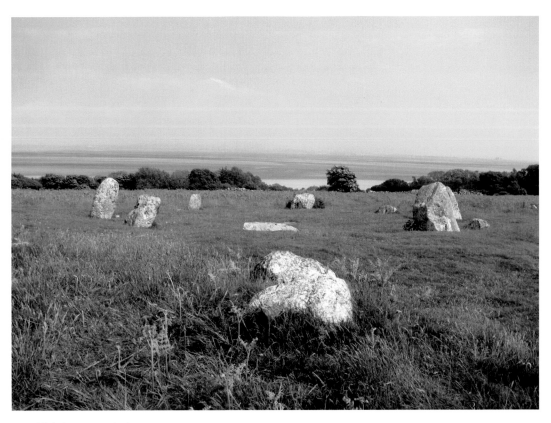

Birkrigg stone circle.

Possible ditch at Birkrigg.

Stainton where some evidence of both Mesolithic and Neolithic settlements and farming have been found.

At Stainton in 2015, five pits and a post hole were found, and exploration of the limestone crevices was undertaken. One of the largest deposits of carinated pottery from the Neolithic period in Cumbria was found. This pottery was simple with curved bottoms, no decoration and was used for cooking or storage of food or grain. Scientific analysis showed the presence of dairy fats within some of the pottery sherds, indicating livestock farming and permanent settlement. Broken polished axes and flint tools, charred grain, bone, and charcoal were found, again confirming the idea of settlement.

During excavations to find a twelfth-century mill at Gleaston, it was suggested that there was a possibility of Mesolithic settlement in the valley. It was proposed that there was a small lake or tarn at this time, tools made from imported flint, chert, and chert and flint fragments were found suggesting settlement. A full report was made, and successive excavations undertaken by Chris Salisbury and his team. A geophysical survey was carried out by archaeologists from Reading University.

With the advent of local building projects archaeological investigations have increased and it is one benefit of development. A recent dig at Holbeck Park Avenue revealed an

Early Neolithic site prior to building more housing. Sheridan, Allen, and Vince reported finding a total of 159 sherds plus various fragments. The collection comprised fifteen carinated bowls; some of the sherds were small, but several could be refitted and joined to determine the type of pottery present.

'Tree throws' are hollows created by the root ball of a tree when it has blown over. This makes a pit which fills with organic materials. These can then be interpreted by archaeologists. They hold valuable evidence for human activity and those at Holbeck Park Avenue were amongst 'the earliest dated episodes of Neolithic occupation on the British Mainland' according to Griffiths in 2011. Cereal grain and carinated bowl pottery was discovered in the tree throw hollow. This is good evidence for Early Neolithic materials and transition from the Mesolithic. Evidence from the tree throws at Holbeck tallied with local pollen data (Appley 2013), indicating that this site was a clearing among deciduous woodland.

These discoveries are providing better understanding of the early occupation in the North West and are pushing back the dates for prehistoric settlement in the Furness area. The Holbeck depositions are important because they are only a few generations earlier than those found at Stainton quarry. The changes towards domesticity, community, gathering, and farming are shown over the time and give a better picture of early occupation than previously recognised.

Gleaston Water Mill, site of a dig to find a seventeenth-century mill.

The Portable Antiquities Scheme was introduced in 1997 and has given opportunities to collate and record metal finds discovered by detectorists. This has obviously contributed to the extent of knowledge and understanding of life in prehistoric Britain. Furness has been no exception and later Bronze Age metalwork has been discovered at Roosecote and Rampside in 2013 and 2014. The detectorist is to be applauded because he didn't clean the artefacts, sensibly leaving that to the professionals. He also donated the Rampside Hoard to the Dock Museum. The Roosecote Hoard was on farmland and the landowner waived his right to a reward and allowed the museum to acquire it at an affordable price.

These two important late Bronze Age hoards were rare discoveries and indicate metalworking was prevalent in the area at this time. The deposits are significant because of their rarity in Cumbria and to find two in the same vicinity suggests they are connected. It's thought they served as a boundary demarcation that was important to the people who buried them.

Furness is an enigma because it was assumed that it is too far off the beaten track to be important historically and until recently archaeological investigations had been sporadic. These are changing long-held views about settlement in Furness. Hints from early antiquarian explorations have been built on and form part of the patchwork of evidence to give a fuller picture.

It was believed that the Roman occupation did not include Furness because there is no substantial evidence for this. However, there were early claims that the Romans did occupy the area. Father Thomas West, a notable antiquarian, claimed in a letter to John Whitaker of Manchester that a 'Roman Castellum' was discovered in Dalton churchyard revealing walls, ditches, and the foundations of a hypocaust. He further theorised that there was a confluence of ancient roads connecting the area to known Roman posts. There is a distinctive gap between Lancaster and Ravenglass, so this is an attractive theory. It was asserted that a road ran from the sands to Conishead, to Ulverston and then Dalton.

Dt William Close, when revising 'Antiquities of Furness', had re-examined a rampart at Dalton churchyard; however, he didn't find any Roman artefacts there. There was a small yet significant find of a lead disc, inscribed with the letters 'SOL', in a garden at Scalegate in Dalton in 1804, not far from the rampart. Sadly, the rampart was removed when the cemetery was extended soon afterwards. West's interpretations were accepted for most of the century, but by the twentieth century various antiquarians challenged them. W. G. Collinwood claimed that although ramparts might have existed, they were related to the town at the time of the Domesday Book. Further challenges came from Harper Gaythorpe, naturalist and antiquarian, who was critical of the veracity of West's opinions. He asserted that there was no clear or tangible evidence of a castellum or Roman artefacts and took this as proof that the Romans did not enter the area.

Finds such as coins and other small artefacts have become more numerous in recent times, which could indicate a Roman presence. Interestingly, small artefacts have been discovered around the Furness Abbey area, including a small statue of a god (possibly Hercules) – now housed at the Dock Museum, Barrow. This prompts the idea that the abbey site may have been used previously, possibly as a sacred site, which the monastery eradicated when it was first built.

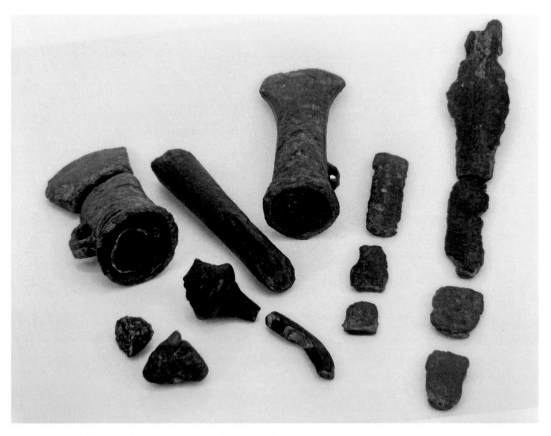

Rampside Hoard. (Courtesy of the Dock Museum)

In 2012 a remarkable discovery was made by a metal detectorist of a silver Roman bracelet in a field at Dalton-in-Furness. It is silver with a separate bezel and is engraved with the seated figure of Jupiter holding a sceptre and a patera (shallow bowl used for offerings). It was a significant find and fundraising was undertaken to ensure it would be placed in the Dock Museum.

Such discoveries are becoming more frequent, probably due to the increased interest in metal detecting and whenever there is a building project, requiring a watching brief before building commences. They do not conclusively confirm that the Romans had any substantial forts or buildings in the area, but they do indicate that at the least trading with the Roman Empire was going on. They cannot have ignored the rich deposits of minerals such as iron ore, and one wonders whether they did utilise it. Until more is found we can only speculate and re-examine the evidence we already have.

As previously mentioned, detectorists sometimes discover things of great importance or interest. In 2011 an enterprising detectorist unearthed a Viking hoard at Stainton, comprising coinage, silver ingots, and a silver bracelet. The hoard was probably buried around AD 955 and is the largest of its kind in the area. Again, these items were saved by donors who raised money to retain them in the Dock Museum, where they now take pride

Left: St Mary's Church, Dalton.

Below: Roman bracelet found at Dalton. (Courtesy of the Dock Museum)

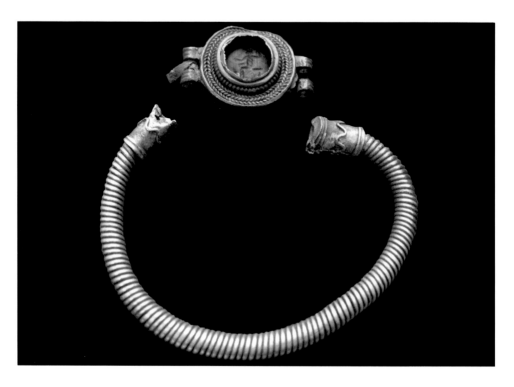

of place in the Archaeology gallery. These are not the first artefacts of the Viking Age to be found but they are the most remarkable.

In around 1854 grave digger William Jackson disinterred a very corroded swordlike object. On closer inspection the object, which was around 12 inches long, had a guard and handle. The pommel had gone, but the style was Viking. Unfortunately, it is unknown what became of this sword, and we have only the written word as evidence that it existed at all. In 1909 another sword was found in the same burial ground. Jacob Helm, the sexton, and his son Thomas revealed it, lying around 2.5 feet deep. The sword was incomplete, the lower part having corroded away. It was recorded and photographed and researched by Harper Gaythorpe.

Other finds from the Viking Age are scattered across Furness, including lead weights from Dalton and whorls from Pennington, such domestic items indicating settlement. Many local place names derived from the Old Norse; for example, Barrai which means either 'island off the headland' or 'bare island', Ormsgill, Yarlside, Biggar, Roa, Rampside (Hrafn's Saetr meaning Raven's seat or farm), Hawcoat (Hacot in Norse). Added to this is the Pennington tympanum adorned with a runic inscription; however, this is early Norman but indicates continued connection with Norse culture. A significant find from nearby Furness Abbey now resides in the British Museum. The Furness Head, as it is known, is a copper alloy head, possibly ecclesiastical, from the eighth century but reused in the ninth century as a Viking weight.

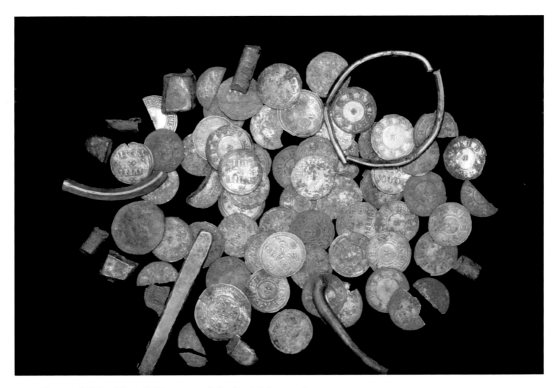

Furness Viking Hoard. (Courtesy of the Dock Museum)

None of this is conclusive proof that the Vikings settled in Furness, but there are certainly some strong links. There are theories, not only for Furness but other areas, that the Norsemen intermarried and traded in the area, leaving behind their language and culture.

These remarkable finds demonstrate that even in early history Furness was very much linked to and part of the wider world. It's likely that the same desire for minerals, arable farmland and natural resources were the attraction for most of these populations.

All left a mark, including the Anglo-Saxons, who we do know settled here. They had settlements at Aldingham, Urswick, Dalton, Kirkby, and Ulverston – all Anglo-Saxon names. They settled in Low Furness principally, avoiding the mountainous fells, but there is a possibility that Coniston may have had Anglo-Saxon beginnings, later occupied by the Viking settlers and farmers. By the time of the Norman Conquest Furness (Manor of Hougun) was under the Lordship of Tostig Godwinson, King Harold's brother. He allied with Harald Hardrada against his brother, and both were killed at the Battle of Stamford Hill. This left the land open for the Normans to supplant themselves.

One of the oldest churches with Anglo-Saxon origins is still in use and is well preserved. St Mary and Michael at Urswick is thirteenth century, but most likely built on the site of a much earlier church. There is some evidence for this because in 1909 a stone from the tenth century was found, and this was later added to by the discovery of another stone in 1911. This stone is known as the 'tunwinni' cross and is inscribed with runes and two figures; the other stone was probably the cross shaft.

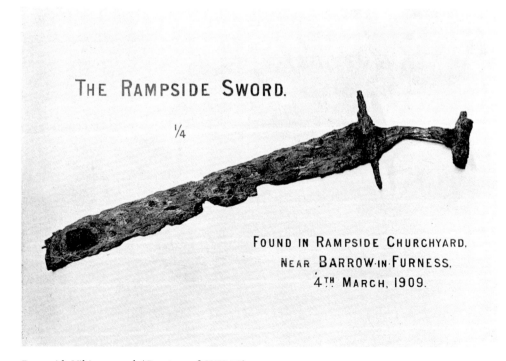

Rampside Viking sword. (Courtesy of CWAAS)

Above: St Mary's and St Michael's Church, Urswick.

Right: Tunwinni stone.

1066 and Beyond

The transition from Anglo-Saxon land ownership to Norman in Furness was complete by the time of the Domesday survey in 1086. The Manor of Hougun, and any fortifications, were ceded to the Crown and remained so until 1092. The Harrying of the North was unleashed by William the Conqueror in the winter of 1069–70 and was vicious and unrelenting. William laid waste to crops, villages and massacred those in his path. Those who survived were left destitute and famine followed. The actions were harsh and disproportionate and couldn't have inspired loyalty to the new regime. As Barnes says, 'Anarchy prevailed in the north, large tracts of land were depopulated and much of the country lay waste and uncultivated. In Furness sixty percent of lands listed in Domesday went out of cultivation.' This was a microcosm of what was happening everywhere in the north and the devastation led people to survive how they could, including piracy.

Henry I had granted land to his Norman barons across the country and Furness was no different. Between 1107 and 1111 he had given tranches of land in the east of Furness to Michael Le Fleming. This was known as 'Muchland'. The remaining land was granted to his nephew Stephen of Mortain and Boulogne, who later became King.

Putting their mark on the region was clear. Following a reshuffle of lands, the two areas were set for different purposes. Le Fleming instigated the building of the church at Aldingham, implanting the Norman stamp on top of the Anglo-Saxon base. It's assumed that an earlier church might have existed, though there is currently no physical proof. This assumption arises from the story of St Cuthbert, whose corpse was alleged to have rested at Aldingham during its seven-year journey. His coffin was carried by monks to protect him from Viking raiders. It is a fascinating church with interesting features, including the grave of Goditha of Scales, probably thirteenth century. She might have been an abbess, but again this is only a theory. In the east wall an aperture exists which goes right through into the chancel, so that lepers could access the service without entering the church.

Le Fleming was responsible for establishing Norman authority with a motte-and-bailey castle at Aldingham. This signalled to the indigenous population that the Normans were in charge. The conical mound was probably topped by a wooden palisade and later a bailey was added. It stood above the sea in a dominant position, visible for miles. Eventually, the Le Flemings moved to an inland location at Gleaston (Glasserton) mentioned in the Domesday record. A substantial fortification was built, with towers and curtain walls. This was inland and constructed with limestone and sandstone details on walls and doors. The high-status building had a hall and a quadrilateral enclosure. It was used until Thomas Grey, Marquis of Dorset inherited it through his wife. It was abandoned later and fell into ruin. The castle today is at risk, and in February 2021 part of the northwest tower fell to the dismay of local enthusiasts. Part of the building was incorporated into the farm buildings during the nineteenth century. The castle is now listed as Grade I – but vulnerable.

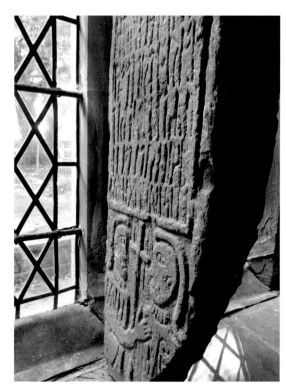

Right: Runic letters on Tunwinni stones.

Below: St Cuthbert's Church, Aldingham.

Aldingham Motte.

The remainder of Furness was administered by Stephen, who granted land to monks from Savigny-le-Vieux in Normandy. Stephen was a benefactor of the Savigniac Order, so it is not surprising that he ear-marked this land for their ministry. The monks first arrived in 1127 from Tulketh in Preston, where they had settled in 1124. The land was ripe for development, and he established the first monastery in Beckan's Gill, a long narrow valley, surrounded by high banks and woodland. The balance of power was soon set between the other landholders and the monks of Furness. The Savigniacs were there for twenty years until the Cistercians subsumed the order. From this point the abbey transformed into a northern powerhouse of agriculture, industry, and land management.

There were other ecclesiastics close by at Conishead, near Ulverston; Gamel de Pennington, another local lord, established a small hospital for the poor in 1160. A school was provided for the local population too. The Augustinian canons who ran the hospital were in prime position when it was made a Priory in 1188. With a higher status the Priory was able to receive land, fisheries, and livestock. They also held a holy relic, the girdle of the Virgin Mary, which added kudos, wealth, and power to the Priory, but brought them into rivalry with Furness Abbey.

There were various influential families who made their mark on the landscape, like the Penningtons, who could certainly date their ancestry back to the Conquest, if not before. They prospered during the early medieval period and beyond. Their castle at Pennington was probably a ring work, with banks and ditches, not a motte like Aldingham. It would

have been a simpler structure, using the natural features in the landscape including the beck to avert intruders. The structure was more likely to have been wooden than of stone. The Penningtons abandoned the site in the early 1300s, building a more intricate and substantial castle at Muncaster, with huge fortifications and an imposing position overlooking the River Esk.

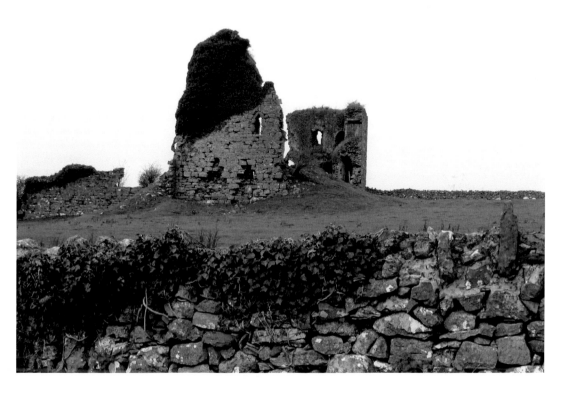

Above: Gleaston Castle.

Right: Conishead Priory. (Manjushri Centre)

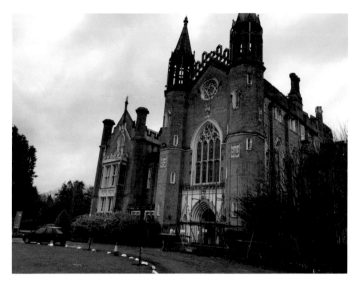

3

Medieval Monastic Dominance

In 1147 the Cistercian Order took over the previously Savigniac monasteries. They followed the Rule of St Benedict and the teachings of Bernard of Clairvaux, originating in Citeaux, France, and were intended to be a simple reforming order. Furness Abbey was claimed by them, and they immediately began eradicating the Savigniac building and implanting their own. The first church was Romanesque in style with a curved presbytery and typical Norman pillars and decorations. Fragments of these can be seen behind the transept, unseen in their time, but revealing chevron tiles in a row today.

The abbey grew to an estimated peak of a hundred Quire monks who ran the abbey. These were educated monks, often taken from the gentry class. They were supported by more than 250 lay brothers who although they took holy orders, had dispensation to miss some of the numerous services to allow them to work the land. Many of these would be outside in the granges and would only return annually to the mother church. The monks provided various services to the local population, including alms for the poor, medicine

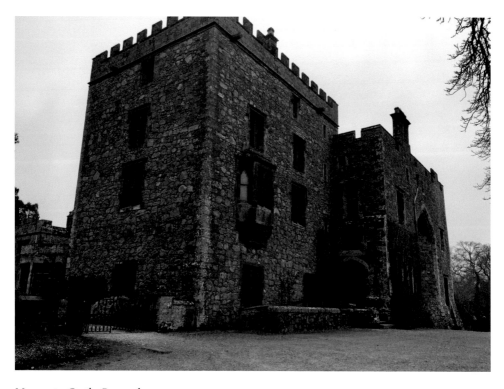

Muncaster Castle, Ravenglass.

for the sick, spiritual guidance, dole (food given from their own table each Thursday) and shelter for travellers. They accepted 'corrodians' or pensioners, who gave donations or land in exchange for care in their later years. One beneficiary of this was William de Graindeorge, a landowner who had real sympathies with the monastic life. He granted the monks land at Flasby and Winterburn and frequently extended lands and access to the monks of Furness. His son, presumably concerned his father would relinquish the whole estate, allowed him a pension of seven marks until his death. Following his time in the abbey William Senior eventually left the monastery and decamped to Flasby as his son's 'guest'. Despite this he was laid to rest in Furness Abbey and there is a stone inscribed with his name in the current museum.

The abbey was an extensive powerhouse of industry, increasing wealth and power with every land transaction. We can see how it thrived by the many architectural additions over the centuries. It had one of the largest infirmaries in any abbey and the final construction, the West Tower, only completed in 1500. The abbot was a powerful man and was closely linked to the state; he had his own lodgings at the abbey where he could entertain important visitors. Additionally, he had an apartment in the Savoy Palace in London, indicating his importance and political influence.

As with most abbeys, the abbey of St Mary of Furness had a certain reputation for learning. There was a school for a hundred boys, taken from the local gentry

 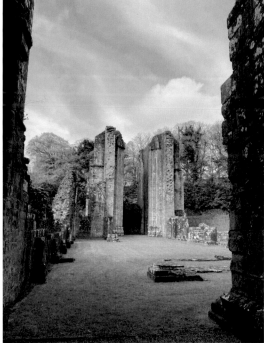

Above left: Tombstone of William de Graindorge.

Above right: West Tower at Furness Abbey, built 1500.

and the poorer classes too. Many of these boys would become novices and later monks, and this was an important centre of education in the district. The renowned hagiographer Jocelin of Furness wrote about the lives of St Patrick (*Vita Sancti Patricii espiscopi*), St Kentigern, St Helena, and St Waltheof. He was well known in his time (between 1175 and 1214) and was a member of the Furness community. His studies focused on Celtic saints and even though Helena (Emperor Constantine's mother) was not strictly classed as this, he did emphasise her Britonnic origins. A serious study of Jocelin and his work has been undertaken by Helen Birkett of the University of Exeter.

Another notable scholar at Furness lived there a century later. John Stell, scribe, was tasked with compiling the Furness Coucher Books. It is fortuitous that these still exist – at the Dissolution they were removed to London, probably to ensure the King had an accurate account of landholdings. Stell was an excellent illuminated letter artist, but slightly less adept at copying. Nevertheless, the volumes contain many interesting facts and documents about the abbey. Abbot William Dalton instructed the monk to create this work in 1412. The cartulary included deeds, charters, land transactions and papal bulls, as well as details of events and history of the abbey. Stell would have been the scribe in charge of the other monks who would assist in copying and inserting illuminated letters into the text. It was a complex and lengthy task, but the result is spectacular. Stell obviously had a cheeky sense of humour as he inserted himself into one of the letters and drew himself in a footnote with a pun on his name.

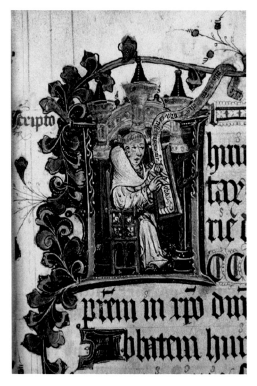

John Stell, scribe of Furness Abbey.
(Picture British Library)

Stell is interesting because there is a rumour that he broke his vow of chastity and fathered offspring. It would be very difficult to prove but there is evidence that he did travel outside the abbey. He was recorded in 'York Clergy Ordinations' as a deacon, with another Furness Brother called Thomas Gronedale on 19 September 1405 in the 'conventual church of the Franciscans, York by Brother William Pharensis, the Suffragan, by the authority of the cathedral chapter of York, the Dean being in remotis and the archiepiscopal see being vacant'.

The abbey was well known and extremely wealthy. Money was made from exporting wool from their many sheepcotes, such as Brotherilkeld in Eskdale, Roosecote, Greenhaume, Ireleth, Sandscale, Mouzel, Thwaite Flat and Stewnercote.

Piel Island belonged to the monks and the castle was used as a storage unit and a port for shipping wool to the Continent. Abbot John Cockerham was given permission for the castle to be crenelated in 1327, probably as a defensive measure after Scottish incursions in 1316 and 1322. Wool was exported via Piel and stored in the castle, and goods were imported too, such as corn and wine, often bringing them into conflict with the Crown. The castle was taken from the abbot's possession by Henry VI and rents from Walney removed to allow the King to offset the cost of the garrison. The issue had been pre-empted by the monks, who had already removed the roof to make it uninhabitable. They gained it back in 1403 and stealthily re-established their control and a resumption of their smuggling activities with Flemish merchants. The castle keep was principally defensive, however the upper floors were for the abbot and the monks, with various chambers for their use. The lower floor provided storage for wool and contraband shipped in and out of the island.

Piel became important in the national story when Lambert Simnel landed with 2,000 troops to usurp Henry VII. He was a ten-year-old boy used by Margaret Duchess of Burgundy to further the Yorkist cause. Lord Kildare and his brother Thomas Fitzgerald planned the attack with Martin Swartz, and they landed at Piel on 5 June 1487. Few local leaders joined them, except for Sir Thomas Broughton. Simnel was alleged to be the Earl of Warwick, a Yorkist heir, despite the real Warwick being paraded through London by Henry VII. They left Piel to meet the King's troops at Stoke. The rebellion failed and the key conspirators were executed, but Simnel was put to work in the palace kitchens.

After the Dissolution the castle fell into disrepair and ruins. A row of pilot's cottages was built in the eighteenth century and there was a customs house on Roa Island. Smuggling was still an issue, but shipping increased and from the nineteenth century the main sea route out of the growing port of Barrow ran past Piel. In 1920 the Duke of Buccleuch donated the island to the people of Barrow as a war memorial for those who had perished in the conflict of the First World War.

A strange custom exists, probably mirroring the Simnel landing and the Pretender's coronation. A ceremony is held, crowning the new landlord of the pub 'King' of Piel. He sits upon an ancient chair, wearing a helmet rather than a crown and holding a sword. He is then anointed with beer and from then commences his reign on the island. This ceremony was last performed in 2022 when Aaron Sanderson became a landlord of the public house.

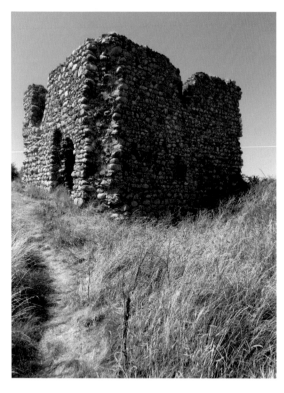

Left: Piel Castle.

Below: Lambert Simnel landed at Piel Island.

The abbey controlled many aspects of medieval life, including judicial matters. The Abbot as Lord of the Manor of Furness was entitled to administer justice to the local people and hear grievances. In 1239 a market, a fair and a Baronial Court were established. The present pele tower is probably a second building, more substantial than the first, built in response to the Scottish raids throughout the fourteenth century. In 1316 Robert the Bruce raided Furness and laid waste the countryside. The final 'great raid' occurred in 1322 when the abbot parleyed with Bruce, allegedly at Dalton (though not in the existing building). He agreed to leave the remainder of the Manor of Furness untouched in exchange for money and livestock. He is alleged to have spent the night at the abbey as the guest of the abbot and the next day he went on his way, devastating everything beyond Cartmel.

Some of the court cases dealt with misdemeanours like not maintaining hedges, sheep worrying, scolding (usually women) and tenants' disputes. There was a jury of tenants to try the cases but if a tenant had a problem with the abbot or a decision, he was then able to go to appeal with a second jury. This judicial power was sacrosanct and if the Sheriff encroached on this he could be fined, and that was forfeited to the King.

The castle is a fourteenth-century three-storey building with a dungeon and courthouse. It was a prison until 1774 and a courthouse until 1925. The abbot was permitted to erect

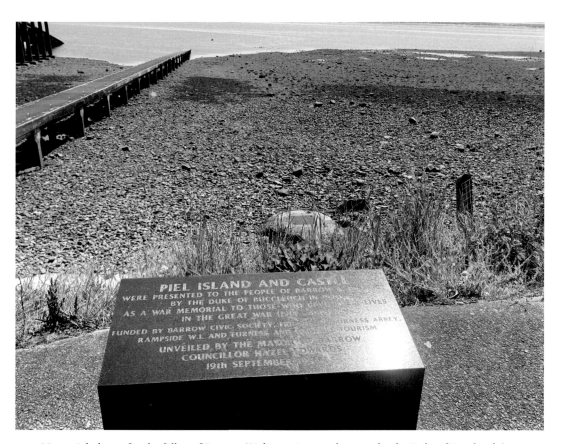

Memorial plaque for the fallen of Barrow. (Piel was given to the town by the Duke of Buccleuch.)

a 'cuckstool' (ducking stool), a pillory for punishment of misdemeanours, and for more serious crimes gallows were erected. Over the intervening years many structural changes and repairs were undertaken. The number of floors was reduced to two and windows altered. Stone from the ruins of Furness Abbey was used to repair the tower. The Duke of Buccleuch was responsible for many of the later changes, and he gifted the tower to the National Trust in the late 1960s and they administer it still.

A different courthouse linked to Furness Abbey was Hawkshead Courthouse, another judicial arm of the abbot. The gatehouse is all that remains of the monastic manor complex. The buildings surrounded a quadrangle – like a cloister with the courthouse on the first floor above the gatehouse. The monks held extensive lands in the Lake District and this centre would have allowed them to administer them through the manorial court and would provide accommodation for the Quire monks when visiting. There would be a chapel for their use and any lay brothers working nearby could also use it. The church at Hawkshead was originally twelfth century and was a chapelry for the abbey until it was adopted as the parish church following the Dissolution of the Monasteries.

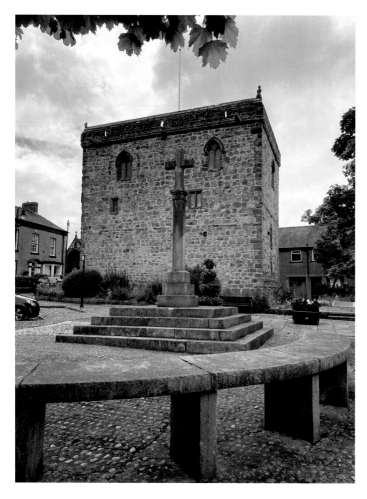

Dalton Pele Tower and Market Cross.

Hawkshead Old
Court House.

The Dissolution changed the area vastly, removing the monks totally from the abbey. Roger Pele, the final abbot, was in constant contact with Thomas Cromwell, offering bribes and hoping to mitigate what would happen to the abbey. His letters record his desperation and his hope that he could change Cromwell's mind. However, this was never a possibility and Furness became the first great abbey to be dissolved and it was systematically stripped bare. Many of the smaller houses had already been destroyed, but Henry VIII was set on liquidating the powerful and wealthy ones. Pele and thirty-two monks signed the Deed of Surrender on 9 April 1537 in the Chapter House. It would not have taken much persuasion for Pele to submit, considering that he knew of the fate of other abbots, such as the Abbot of Whalley.

The abbey was stripped of anything valuable, starting with its contents and furnishings. Dr Michael Carter recently discovered an inventory from Robert Southwell, the Commissioner in charge. It reveals that 'speculators' from the south were poised ready to capitalise on the abbey's demise. Details of the sale of some items were listed, such as the bells; these were sold to Kendal for £80, which was a large amount of money. It is suspected that some of the plate was secreted away by the monks prior to the arrival of the Court of Augmentations men as there was less than expected. Lead was stripped from the roof and windows and melted down to be sold, timbers were brought down and sold, glass and tiles presumably the same. This thoroughness is why we have little evidence of glass, tiles, or personal items as is found in other abbeys such as Byland.

There is one beautiful piece of glass found on site, by John Petty of York, depicting an angel from the fourteenth century. This is held by English Heritage and appears to be the only piece which is verifiable. Small fragments of medieval glass are found in Urswick church and Dalton and are probably authentic, but they cannot be proven to come from Furness Abbey.

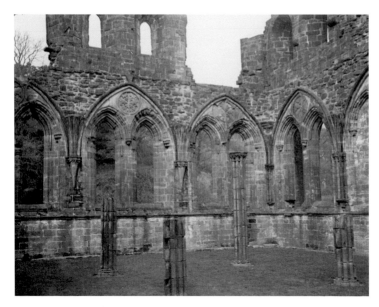

Above left: The Chapter House at Furness Abbey.

Above right: Thirteenth-century painted glass of an angel ascribed to John Petty of York.

St Mary's Church at Dalton has some interesting pieces from the abbey, removed post-Dissolution. There is the abbey font (a sink or basin), now used for baptisms and made from sandstone. It has the abbatial shield carved on the front, showing a crozier. The present altar was refurbished using foundation oak logs from Furness Abbey in 1930 and houselling benches were also constructed using this material.

The abbey walls were pulled down using 'ropes and other engynes', the fallen masonry reused or taken and is easily identified in buildings across the district. This abbey was a test case for the others and showed how much money could be accrued from the destruction. It is quite satisfying to learn that due to the market being flooded with lead (from other religious houses) that the profit from this was less than Henry had hoped for. That said, they made approximately £800 in total, but this was offset against smelting costs, clearing the abbey debts, demolition costs, Commissioner's fees, and payments to the monks, which took the profits right down to £367.

The Preston family retained the abbey and grounds and later built a manor house from stone retrieved from the ruins. The rest of the building was left to moulder and fall, with frequent removal of stone for repair and building work, for example repairs to Ulverston parish church. The site was passed from the Prestons to the Lowthers and latterly the Cavendishes. Its importance changed but was still generally revered and eventually recognised as an important heritage asset.

The abbey fell into ruin and disuse, and much of what was left became overgrown and tangled with vegetation. There are early etchings of the abbey showing shepherds grazing sheep and people enjoying the grounds. Wordsworth is known to have ridden through the ruins as a boy when he holidayed at Rampside. The ruins were appealing to the Romantic

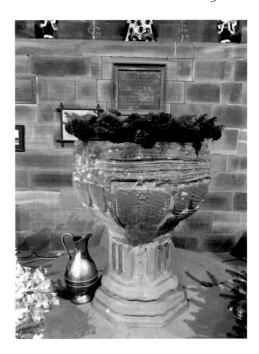

Right: The font in Dalton St Mary's Church.

Below: Altar at Dalton Church.

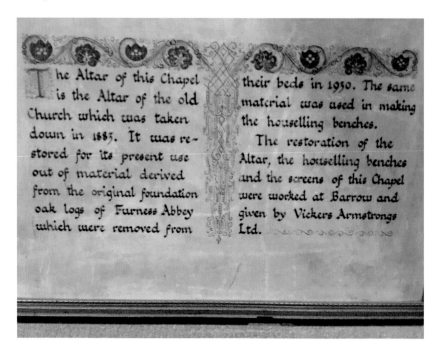

The Altar of this Chapel is the Altar of the old Church which was taken down in 1885. It was restored for its present use out of material derived from the original foundation oak logs of Furness Abbey which were removed from their beds in 1930. The same material was used in making the houselling benches.

The restoration of the Altar, the houselling benches and the screens of this Chapel were worked at Barrow and given by Vickers Armstrongs Ltd.

Left: Plaque in Dalton Church.

Below: The Preston Manor House at Furness Abbey.

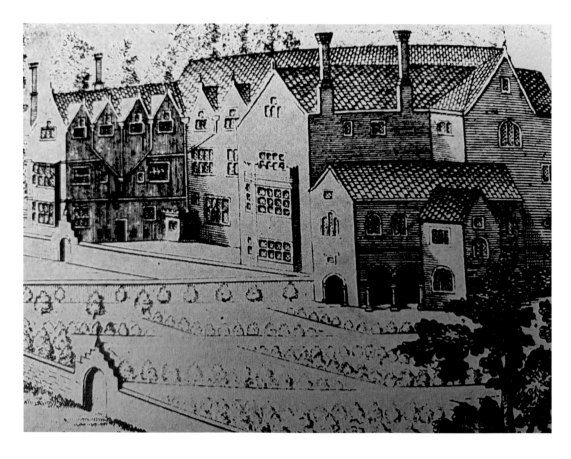

movement, with Wordsworth writing two poems about it. JMW Turner detoured from the Lake District to visit and sketch the abbey in his 'grand tour' in 1793. His sketches are delicate and capture the tranquillity of the abbey admirably. Wordsworth (probably the world's first 'nimby') objected strongly to the railway and its proximity to the East Window. Luckily, the line was taken through a tunnel to divert it from encroaching too closely. However, for Wordsworth this was not enough: he called the railway company 'Profane Despoilers' in 'At Furness Abbey', while in a second poem he declaims the Duke of Devonshire 'Where Cavendish "thine" seems nothing but a name!'

In the 'Prelude' he recalls his youthful visits to the abbey in 1805 in a gentler and less angry description of the ruins. In this piece he recalls statuary which is still familiar to us today and which resonates just as clearly as they did with him – though perhaps we would not ride through on a horse!

> With whip and spur we through the Chauntry flew
> In uncouth race, and left the cross-legged Knight,
> And the stone-Abbot, and that single wren
> Which one day sang so sweetly in the nave
> Of the old Church...

The 'rash assault!' became a cause celebre during the 1870s, thirty years after Wordsworth had first called out the destruction of the environment. In the early years he gained

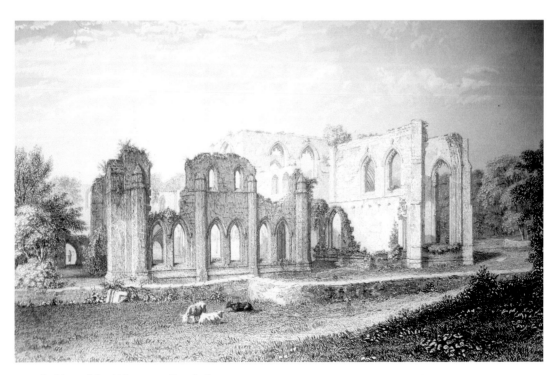

Etching of the Abbey post-dissolution.

little support for his protest despite having lobbied parliament and written to the press. However, when the railways were expanding and were no longer a novelty, opposition grew. The artist, philosopher and critic John Ruskin joined in the protest. Although not local like Wordsworth, he felt the despoiling of the abbey and the wider Lake District just as profoundly. He refused a medal from the Royal Institute of British Architecture in remonstration of many of the modern innovations and changes which he deemed inappropriate. One of these was the closeness of the railway to Furness Abbey. If Wordsworth was the first 'nimby', then Ruskin perfected the role! He wrote flurries of letters to the press. He joined Robert Somervill in lamenting and petitioning against the degradation of the Lakes and it was not only the infrastructure he objected to; the possibility of tourists horrified him. They argued that it was not about exclusivity, but more about wanting to retain and conserve the heritage and natural environments.

Ruskin was less than complimentary when he wrote the following:

> The stupid herds of modern tourists let themselves be emptied like coals from a sack at Windermere and Keswick. Having got there what the new railway has to do is to shovel those who have come to Keswick, to Windermere-and to shovel those who have come to Windermere, to Keswick. And what then?

He continues in the same vein, which I am sure some of us will identify with:

> To open taverns and skittle grounds round Grasmere, which will soon, then be nothing but a pool of drainage, with a beach of broken ginger beer bottles; and their minds will be no more improved by contemplating the scenery of such a lake than Blackpool.

I am sure his concerns were sincere, but there does appear to be an element of privilege in there. After all, as an 'off comer' Ruskin was hardly in the position to prevent others from enjoying what he saw daily. Naturally, these views must have informed the likes of Canon Hardwicke Rawnsley who later helped to establish the National Trust and was the start of the environmental lobby.

The abbey itself was thrust headlong into the tourism industry. Devonshire owned the ruins and as the railway now ran so conveniently past them, he saw the main chance of creating a passenger railway for leisure. Indeed, the station at Furness Abbey was on the main line to Barrow and as time went on the line was expanded past Ulverston to Lancaster. This offered a range of possible customers who wanted to take excursions and Furness Abbey was included in the publicity for tours to the Lakes. Furness Abbey Hotel was built in 1847 using recycled stone from the abandoned manor house in part, a grand building with thirty-six rooms and three bathrooms, somewhat less than would be required today. Sharpe and Paley were responsible for numerous buildings in Barrow, and this was one of those. In the 1860s it was extended by EG Paley, linking it to the new station. The hotel had a sitting room, a ballroom, a billiard room decorated with stained glass and including some carvings and artefacts from the abbey itself.

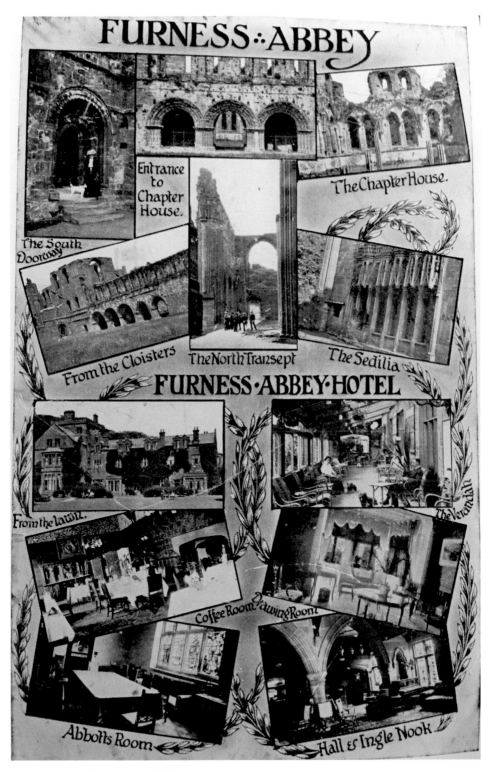

Postcard advertising Furness Abbey Hotel.

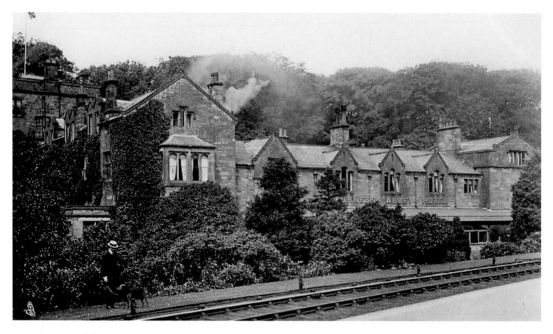

Furness Abbey Hotel. (Sankey Collection)

There were several famous visitors the hotel and abbey ruins; it naturally attracted the artistic and intellectual minds of the time, some of whom we have already mentioned. Rupert Potter visited with his family on 13 September 1900. He took many photographs, and he was accompanied by Beatrix, his daughter. Some of the photographs still exist and are an excellent depiction of the abbey at the turn of the twentieth century. Queen Victoria visited in 1848 with her lady in waiting, Augusta Stanley, one of numerous royal visits in following years. A young Theodore Roosevelt played with his siblings in the abbey grounds, running freely through the ruins in 1869. Other visiting dignitaries visited including Chinese viceroy Li Hongzhang in 1869 while touring industrial towns in the north of England. In 1988 Prince Edward visited the Mystery Plays and the author Melvyn Bragg attended. The 1988 play was the last of a series which had begun in the 1950s. They were very popular and are still remembered fondly. Many celebrities have visited over the years and the author had the pleasure of escorting Dan Snow, historian and TV presenter, around the ruins. His response was one which is often expressed by visitors seeing the abbey for the first time: 'Why did I not know about this? It's amazing!'

The abbey was a central attraction and was open to hotel residents. In 1910 a small hut was built to accommodate the custodian and tickets were purchased here to visit the grounds. It fell from use in 1982 when the new visitor centre was built, horrifically brutalist in style and an incongruous addition to the ruins. Furness Abbey was the first heritage site in the UK to have a dedicated custodian and guide, well in advance of its time beginning in the 1850s. He was given a cottage, named 'the Custodian's Cottage', on the edge of the grounds. This was an adapted medieval building, now known as Abbey Mill

Visit by Dan Snow, TV historian, to Furness Abbey.

Café. It suffered vandalism in the 1990s and was set on fire. Luckily, it was not destroyed, but the loss of the roof was catastrophic as this was the only remaining roof dating from medieval times.

Furness Abbey Hotel was damaged during bombing in 1941 and demolished in 1953 leaving the northern wing intact. This was the second-class buffet and ticket office originally and was integral to the tourist trade. It later became a bistro and tavern, popular in its day, but now empty. English Heritage have bought the Grade II listed building and are seeking a sustainable use for it.

Years of weather and wear have taken their toll on the monastic buildings, and English Heritage battle to conserve the sandstone relic. When cracks appeared in 2007 investigations of the foundations were undertaken. It was found that the oak rafts had shrunk and deteriorated over time due to the change in the water table. Some of the oak had dried out and shrunk, causing movement in the stonework above. Archaeologists dug out the presbytery and prepared to remove them ready to replace with concrete beams. During the work a huge purpose-built iron structure was put in place. This was designed to 'catch' the walls if they moved rather than anchoring them totally. This structure is still in place even though the building is now stable.

Old Ticket Booth, built 1910.

The Abbey Tavern, originally the second-class buffet and ticket office for Furness Abbey station.

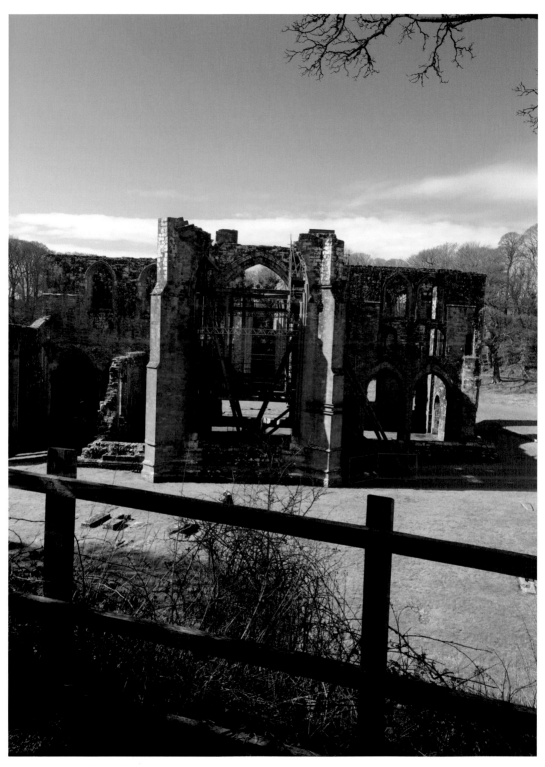

The Presbytery with a purpose-built support.

As a Scheduled Monument excavation must be undertaken by professional archaeologists and everything was recorded. Oxford Archaeology North led the first few seasons investigating the foundations in the presbytery. Early discoveries revealed the altar from the Savigniac church, and the curved apse of the original Romanesque church. In 2010 an even more fascinating and rare discovery was found about 1.5 metres deep and close to the position of the altar. Among the other burials was a very significant skeleton buried with a crosier and a ring on his finger, suggesting this was an abbot or a bishop. It is known that at least two Bishops of the Isles were buried at Furness, so this was a possibility. However, it was decided that it was more likely to be an abbot, albeit a revered or special one. The excitement was palpable as this type of monastic burial is very rare and the grave goods were in decent condition.

Investigations showed that the man had been alive roughly between 1380 and 1490, and that he was 5ft 7inches tall and between forty and fifty when he died. His bones and teeth were healthy, indicating a good diet throughout his life. This probably meant he was from the gentry class and went into the church as a young man. The monastic diet was a healthy one and was more than adequate, unlike the diet of the peasants. He was also obese, so had a rich diet during some of his lifetime. We know this from the lay of the arms, which instead of falling into the ribcage have slipped off a large upper body to his sides. He had type two diabetes, and dish (diffuse idiopathic skeletal hyperostosis) in his spine, a common predisposition arising from monastic life. He was found to have

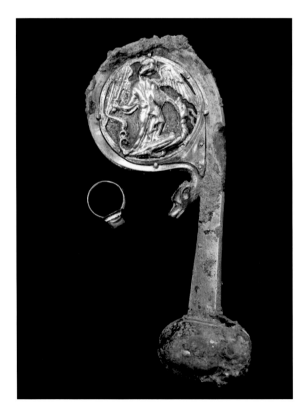

Crosier and ring found in 2010 at Furness Abbey. (Courtesy of English Heritage)

arthritis in his knees and the DNA defined that his diet consisted of 50 per cent of marine fish and animal protein. These medical conditions would have caused pain, debilitation and discomfort. He probably would have died from a stroke or heart attack arising from untreated diabetes. Added to his discomfort was a ring with a pointed bezel, designed to irritate reminding him that he owed his good fortune to God. If he was overweight the ring must have been tight and would have pinched him to wear it.

His crosier was made from gold and alloys dating from the twelfth century. It had been altered and was old even when it was put in the ground. The silver disc depicts St Michael the Archangel, the defender of the church. This might hint at which abbot this is: the icon obviously has significance to him, and we know that the abbey funded the chapel of St Michael at York Minster. There may be a record somewhere of an abbot who supported a Michael cult that would link to this artefact. Of course, we may never know who he was, but we can be sure he was important in some way, either because of good deeds undertaken or being in the possession of an inflated ego, demanding such a central position in the holiest part of the church.

Change, Education, and Inspiration

The days of the abbey and Roman Catholicism ceased from 1537, but this heralded in religious difference, persecution, violence, and conflict. Some of the repercussions will be mentioned in the following chapter.

The abbey had been the predominant centre for spiritual administration and the market and fair conveyed to Dalton gave it distinction. After the Dissolution in 1537 the sphere of influence shifted. There was a general hiatus at first, with large gaps in the provision for the poor and infirm – the social functions that the abbey had performed had to be picked up by the parish in a piecemeal fashion initially. Eventually, things settled and for example the monastic court at Dalton Castle became the Court where justice was dispensed increasingly by a Justice of the Peace.

In the seventeenth century Dalton's influenced waned, chiefly due to the main market being moved to Ulverston who had been granted a Charter as early as 1280. This stimulated growth in Ulverston and it was noted by Sir Daniel Fleming in the 1670s that it was a good market, especially for the sale of corn. The inns and beerhouses were permitted to open from 10.30 a.m. until 11 p.m. on market days, which helped to increase trade in the town. The parish church was a focus and there were numerous chapelries as well, which became more autonomous as the parish expanded.

Education of course had been limited since the demise of the monasteries, but local benefactors began to fill the gaps. Town Bank Grammar School was established in 1658 by the benefactor Thomas Fell. It's uncertain how effective the education was as according to one pupil the only possibility of progress was 'by removal to a distance of sixteen miles, to the town grammar school at Hawkshead'. That pupil was John Barrow!

This school endured until 1900 and was then replaced by Victoria Grammar School, the endowment now falling to providing two scholarships.

Victoria Grammar School was built in the traditional way, around a quad. This building has survived and is still used, although there are modern buildings surrounding it. The Lower School in Hart Street didn't survive and is now housing. The school is now known as Ulverston Victoria High School and dominates the site on Springfield Road.

Other schools emerged in the town and the National School (Church of England) in 1884 was enlarged and the infant school rebuilt in 1896. The new National school was built at Dale Street in 1876 and again enlarged ten years later. There are now four primary schools in Ulverston: Croftlands (infant and junior), Sir John Barrow, Church Walk and St Mary's RC School.

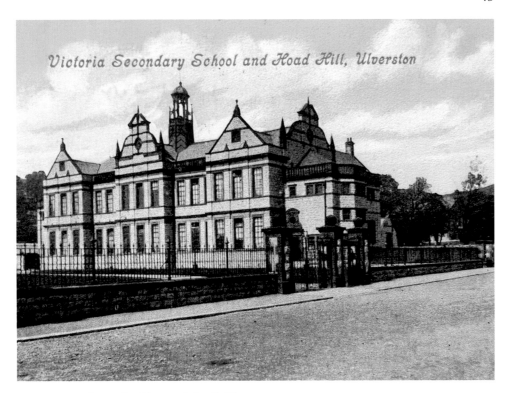

Victoria Secondary School (Lower School), Ulverston.

Although Dalton had been close to the epicentre for education, post-Dissolution it had to produce its own education. There is documentary evidence that in 1533 a former monk, William Rede, had set up a simple school in the town. He was removed because he had objected to William Ashburner encouraging the payment of Peter's Pence (a papal payment which was in contravention of the Act of 1534 forbidding this) and sharing the teachings of Erasmus. This would imply that Rede was of the reforming persuasion in opposition to the powers that be in Dalton. Religion was in flux at this time and heralding further religious conflict to come.

In 1622 Thomas Boulton bequeathed £220 to establish a school. It was stipulated that a copy of the endowment for the school would be kept by the trustees and read every Easter in church to ensure the continuance of the free school. It was situated at Goose Green below the cliff, which in later centuries was where the Green's School was built. The Green's School was closed in 1969 and replaced with the new Dalton St Mary's CE Church School on Coronation Drive to serve the population of the new council estate.

Dalton established its Grammar School in 1746 at Beckside, closed in around 1876. The building still exists as a private dwelling though previously it had been used as a chapel for the Welsh Calvinists.

The current senior school is Dowdales (named after the adjacent field, 'Peter Dowdale's Field'), which is housed in Ashburner House and greatly expanded nowadays. The mansion was built in 1895 originally for GB Ashburner. It became a school in 1928 and

Chequers Serviced Apartments, which was the Green's School. (Courtesy of Gail Cowan)

Old Grammar School, Dalton.

served the communities of Dalton, Askam and Ireleth. It is Grade II listed and has some beautiful architectural features. The school has grown around this and has extensive modern buildings to accommodate the pupils.

Ulverston was notable for the arrival of the Quaker faith and became a centre for its promotion. Judge Thomas Fell was regarded as a leading Puritan in the area and he was named as a commissioner for the safety of the county by Oliver Cromwell. He rose to prominence in 1645, becoming a member of parliament for Lancaster. He became a bencher for Gray's Inn and a judge for the Assizes. In 1652, whilst away at the Assizes, his wife, Margaret had welcomed the preacher George Fox into their home at Swarthmoor Hall. Fell must have been alarmed at this news because he rushed home to discover what was happening. He discussed Fox's doctrines and though he was not opposed to them, he never became a Quaker. Margaret did. Fell's friendship and support for the Quakers brought some conflict, but he was still taking cases in London. He distanced himself from the Lord Protector, Cromwell, because he disagreed with his interference in both temporal and religious issues. When he died, he had withdrawn from politics and was buried at Ulverston, and the records tell us he was Chancellor of the duchy of Lancaster.

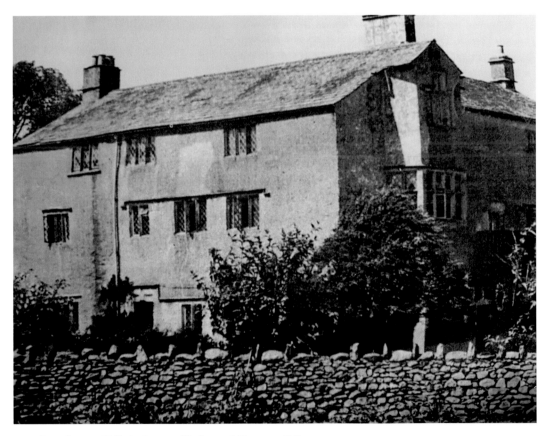

Swarthmoor Hall, the home of Judge and Margaret Fell.

Margaret Fell was born Margaret Askew of Marsh Grange, off Tippins Lane in Kirkby Ireleth, and was originally a monastic grange. The Askews had lived at the Grange since before 1551 and Margaret was the daughter of John Askew, inheriting around a third of the estate. It is possible that the other beneficiaries were bought out by Judge Fell but this created tenancy issues between the Askew and Rawlinson families. The house is a listed building but has been separated into two dwelling houses.

Margaret married Thomas Fell in 1632 and had several children. In 1652 her path changed when she met George Fox and was converted to the ideas of Quakerism. She was in a privileged position as a member of the local gentry, and she frequently intervened on behalf of persecuted preachers. She married Fox after her husband died and became a leading light in the Society of Friends. Quakerism was not without its detractors and Fox was thrown out of the parish church at Ulverston, stoned and run out of North Scale for 'convincing' (converting) James Lancaster, barely escaping with his life. Margaret spent four years in jail in 1664 for allowing Quakers to worship at Swarthmoor Hall and for refusing to take an oath. She used the time to write religious tracts and was quite revolutionary in her thinking. She wrote 'Women's Speaking Justified' which outlined the argument for women's ministry – she was way before her time. She is buried at the Quaker burial ground at Sunbrick and her home is an important centre to this day.

Quaker burial ground at Sunbrick.

The Fells were witnesses to the worst conflict on English soil for many years. The Civil War began in 1642 and divided not only the country but families. It additionally provided a fertile breeding ground for new religious movements such as the Quakers. Reaction to these progressive and evangelical movements was varied and sometimes violent, as demonstrated by the treatment of Fox in Ulverston and North Scale. They were violent times, probably more so because of the background of the Civil War. The district was split both religiously and politically and a battle ensued at Lindal on 1 October 1643 between local Royalists and troops loyal to Parliament.

The Royalists were led by Sir William Huddleston of Millom who had captured and imprisoned several leading local Parliamentarians in Dalton Pele Tower. Some of the prisoners escaped and were able to warn Colonel Rigby, who was engaged in a siege at Thurland Castle at Kirkby Lonsdale. Five hundred infantry, three cannon and three small horse troops were despatched the next day. Awaiting them were approximately 1,800 Royalists, on horse and infantry. They massed on Lindal Cote, blocking the road to Dalton. A stand-off lasted for over an hour and it was not until the Parliamentary force charged that the line broke. The Royalist horse troops retreated, followed swiftly by the foot soldiers. A short skirmish ensued and was over in less than an hour. The Royalists were routed and hunted down. Numerous Royalists drowned while trying to escape across the treacherous Duddon sands. Huddleston and around 400 men were captured and taken prisoner. The Parliamentarians must have been astounded by the ease with which they won, especially as they only suffered two injuries, one of whom shot himself accidentally. Certainly not a glowing victory.

Of course, there are numerous 'sons' (and daughters) of Furness of note; to record them all would require a separate book, so I have highlighted those who have made their mark in some way. There are also some 'off-comers' or visitors passing through who have contributed to Barrow and its environs and therefore it would be churlish not to mention them too.

Surprisingly, this area has often thrown up some unique people, with ideas ahead of their time. Margaret Fell obviously drops into this class and she was not alone. Father Thomas West, a Scot by birth, settled here in 1767 following the closure of the Jesuit colleges in France.

The Furness area had maintained the 'old faith' and there were numerous notable recusants. The Preston family (who gained land at Furness Abbey from the Dissolution) were staunch recusants and Sir Thomas Preston became a Jesuit in 1674. There was a list of Roman Catholic priests who lived at Furness Abbey Manor. The Knype family home at Rampside was a refuge for priests and they lost wealth and land because of their stubborn recusancy. Similar families were the Lacy's of Newbarns and the Bardseas of Bardsea Hall. Yet when West took up the post of chaplain for the Strickland family of Sizergh Castle and priest for Furness, it was recorded that only a handful of Catholics lived in the area. This probably wasn't accurate. He therefore found time to work on his passion for antiquity.

While he lived at Tytup Hall near Dalton-in-Furness he wrote the acclaimed and comprehensive *Antiquities of Furness* which recorded the ruins of Furness Abbey and attempted to tell its history. Some of West's assertions rely on local folklore or surface

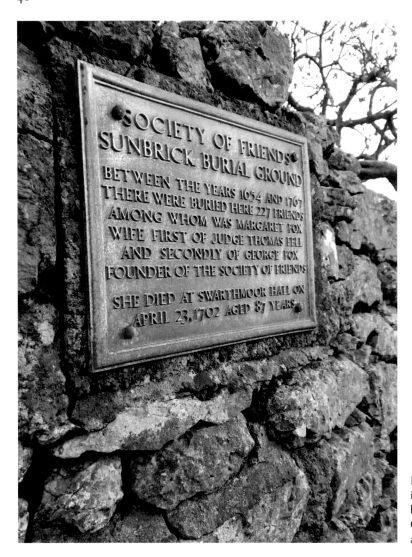

SOCIETY OF FRIENDS
SUNBRICK BURIAL GROUND

BETWEEN THE YEARS 1654 AND 1767
THERE WERE BURIED HERE 227 FRIENDS
AMONG WHOM WAS MARGARET FOX
WIFE FIRST OF JUDGE THOMAS FELL
AND SECONDLY OF GEORGE FOX
FOUNDER OF THE SOCIETY OF FRIENDS

SHE DIED AT SWARTHMOOR HALL ON
APRIL 23, 1702 AGED 87 YEARS

Plaque identifying the burial ground as Quaker burials are not marked.

evidence from the site. It was probably the first proper history of the abbey, and it is still a valid piece of research. West continued to write and published *A Guide to the Lakes* in 1778. He died in 1779 and is buried in the Strickland family vault in Kendal Parish Church.

His work was so well regarded that a young polymath called Dr William Close, who lived at 2 Castle Street, Dalton, took the work and added to it and provided illustrations. He promulgated the idea of the Roman castellum at Dalton just as West had done and developed the idea of the Romans as early settlers. He wrote in his own right too, and apart from the eighty-six-page addendum to West's *Antiquities*, he scribed *History, Topography and Archaeology of Furness*, cataloguing many unique details of the area and its traditions. His final work was *Itinerary of Furness and the Environs*, which had he lived would probably have rivalled West's *Guide to the Lakes*.

Rampside Hall, known as 'Twelve Chimneys', home of the Knype family.

As if this wasn't a large enough legacy, Close in his brief life of thirty-eight years was a surgeon and apothecary. One aspect of this part of his career was the amazing work he did in the village of Rampside. In 1799 he inoculated the whole village against smallpox – this was only three years after Edward Jenner's vaccination for the infectious disease. It was a daring thing to do, especially in a rural and superstitious community. He even took up residence there and inoculated the poorer children at his own expense. This 'experiment' – which is what it was – demonstrated the efficacy of inoculation and within five years the district was free from smallpox. He took the health and well-being of his patients seriously and befriended them. Some of his patients were miners and he was concerned for their safety. He designed and made a new safer lamp for the miners to use underground and a safer method of sand-tamping explosive charges. These were both innovative and useful and underlined his genuine care for the local people.

If we stopped here, this would be a remarkable litany of genius, but Close added other inventions to the list. He made an indelible ink, to allow the preservation of documents and to prevent fading of text. He was a talented musician with interest in brass instruments, and he created improvements for the very simple instruments of the time, including a 'drainage spittle cock', additional holes to increase the range of notes and scales; he even

The Castle Street, Dalton, home of Dr William Close.

made instruments using his improvements and sold them as 'polyphonian' instruments and delivered a paper to the Society of Arts and Manufacturers.

Close even ventured into the world of hydraulic engineering, producing a doubly encased water-filled container jacket to produce an airtight seal for industrial condensers. He wrote a paper on reclamation of land from the sea and drew up a business plan to dam up Walney Channel. The landowners, however, rejected the idea. He invented several pumps and hydraulic engines.

Few people remember his name and achievements, despite his home having a plaque to commemorate him. He died in 1813 and was buried on Walney Island in an unmarked grave, as he requested. He was recalled by Harper Gaythorpe, a nineteenth-century historian and founding member of the Barrow Naturalist's Society. He was best described by a contemporary, 'a little, slender man, very clever, but rather changeable ... and one who devoted himself assiduously to his professional duties'.

Another antiquarian, Thomas Alcock Beck, produced *Annales Furnesienses* in 1844, a similar history of Furness Abbey to West's. Beck was disabled and confined to a wheelchair for most of his life, but this did not deter him from investigating the abbey history. He lived at Esthwaite Lodge at Hawkshead, which was designed by George

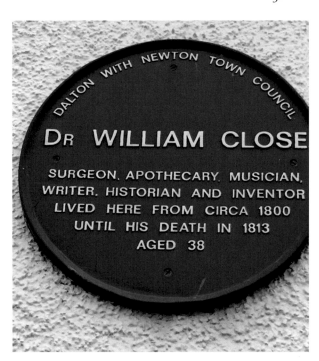

Right: Plaque for Dr Close.

Below: Plate from Beck's *Annales Furnesienses*.

Webster to accommodate his disability, with slopes in the garden to assist his access. His grand opus included extensive research about the abbey and the Furness district and is still used by researchers today. He also edited Close's unfinished *Itinerary of Furness*. He died in 1846, aged fifty.

Rising from humble beginnings in Beckside Dalton-in-Furness, George Romney achieved national fame. The family moved to High Cocken (the cottage is still there) and Romney was brought up there. He was schooled at Dendron but was withdrawn at eleven when he was apprenticed to his father's cabinet-making business. He left for Kendal in 1755 to train as an artist in the studio of Christopher Steele. The following year he made a rash marriage that produced a son. Mother and father were soon separated when Romney left for to York. The apprenticeship was cancelled by Romney's father, and this essentially allowed him to make his own way as an artist. He returned to his wife in Kendal and began work as a portrait, landscape, and historical artist. He left his family again in 1762 for London, to build his reputation as an artist. He rarely lived with them again, but always supported them financially.

He made an impact on the London scene, winning prizes and being invited to join the Royal Academy of Arts. He would not join on principle, which restricted his influence and progression. He wanted to be recognised on ability alone, not royal patronage. He visited

Romney's Cottage at High Cocken, Ormsgill.

Paris, making friends and contacts, and later visited Italy. He exhibited his painting of Sir George Warren and family in 1769 which really established him.

He researched art in Italy and acquired permission from the Pope to study Raphael's frescoes in the Vatican. He spent two years in Italy visiting all the important artistic centres and sketching. He was in debt on his return to London, but his fortunes soon changed when the Duke of Richmond commissioned him and from there the word spread. In 1782 he was introduced to Emma Hart (later the notorious Lady Hamilton and mistress of Lord Nelson). He was captivated by her beauty and grace, and he painted sixty portraits of her through the years. His portraits included many contemporaries, and he was now one of the most renowned portrait painters of his age. In 1797 he left the Cavendish Square studio where he had painted for two decades and bought a house in Hampstead. This house is now Grade I listed and has a blue plaque to commemorate him, despite him living there only for two years.

By 1799 his health was in decline, and he returned to Kendal. Surprisingly, his abandoned wife kindly nursed him for the remaining two years of his life. We can only speculate as to why she was so forgiving. He died in 1802 and is buried in St Mary's Parish Church at Dalton-in-Furness in a somewhat understated tomb considering his importance.

George Romney's grave at Dalton Church.

Furness has produced some very talented people who inserted themselves into the wider national record. Sir John Barrow is a fine example of this. He was born in a humble cottage at Dragley Beck, now part of Ulverston, the only son of a tanner and educated at Town Bank. He showed an aptitude for maths and was bright even though formal education ceased at thirteen. He set up a Sunday school for the poor and underprivileged children of Ulverston after leaving school, showing great altruism for someone so young.

He left for Liverpool and was employed as a superintending clerk for an iron foundry. He went on a whaling expedition to Greenland at sixteen, developing a lifetime interest in exploration. When he returned, he took a teaching post in Greenwich, and this helped immensely because he taught the son of Sir George Staunton who was able to promote his career. He was part of the first British emissary to China under Lord McCartney. He became fluent in Chinese, which enabled him to contribute to the Quarterly Review. He made regular contributions and retained an interest in China for the rest of his life, often being consulted by the government on relevant issues.

In 1797 he accompanied Lord McCartney to South Africa to support the establishment of a government in a new colony at the Cape of Good Hope. He was responsible for liaising

Sir John Barrow Cottage, Dragley Beck.

with the Boers and the indigenous black population and was tasked with reporting on the interior of a relatively uncharted continent. He recorded his travels, building his reputation as a geographer and writer. However, he was not without his critics, in large part due to his less than accurate mapping skills. He married in South Africa, staying for four years until 1804, when he returned to England, becoming the Second Secretary to the Admiralty for forty years. He even remained in post during a change in government, probably the first time such a position was non-partisan. During his office the role was renamed 'Permanent Secretary' and introduced the idea of civil servants' impartiality supporting whichever government was in office.

Following the Napoleonic Wars Barrow was responsible for deploying the large fleet which had developed. He encouraged global explorations to West Africa, the northern polar region, and Canada whilst attempting to discover the Northwest Passage. He became a founder member of the Royal Geographic Society in 1830 and is remembered in many places across the world, for example Barrow Straits, Barrow Sound and Barrow Point in the Arctic and Cape Barrow in the Antarctic.

In 1835 he was made a baronet by Sir Robert Peel, later retiring from public life in 1843 to write about Arctic voyages and his autobiography the following year. He died in 1848 leaving a mixed legacy. It does not take a great leap of imagination to realise that he was partly instrumental in the promotion of imperialism and plunder of resources. He was of his time and would have seen the African continent as a resource for Britain, without acknowledging that this took advantage of the civilisations already there. However, his early altruism was still evident as he did attempt to find a humanitarian settlement for the black South Africans. His success in this is debatable, but his achievements can't be ignored.

Barrow is remembered in his hometown with a monument on Hoad Hill above the town. Known locally as the Pepperpot, Hoad Monument is a replica of the Eddystone Lighthouse built in 1850–51. Barrow's two sons, Sir George and John Barrow, laid the foundation stone and 8,000 townsfolk climbed Hoad Hill to see the dedication. It is maintained by Ulverston Town Council and is lit up at certain times, though it has never functioned as a lighthouse.

Ulverston produced an internationally famous son, Stan Laurel, who was a silent movie star and later partnered Oliver Hardy in a comical duo. Stan was born Arthur Stanley Jefferson in 1890 at 3 Argyle Street (originally Foundry Cottages), his grandparents' house. His father was a theatre manager and showbusiness was in his blood. Stan joined Fred Karno's comedy troupe which toured in America, and from there he worked in silent movies, as a writer and performer for Hal Roach Studio. He teamed up with Hardy and the rest, as they say, is history. He returned with Hardy to his hometown in 1947 to large crowds. They greeted the fans from the balcony of the Coronation Hall. A Laurel and Hardy Museum is appropriately housed in the Roxy Cinema, a 1930s cinema in keeping with the era in which Laurel and Hardy were at the peak of their careers. The Cubin family still have an interest in the museum and have carried on the work of Bill Cubin who initiated the first exhibition. The crowning glory is the statue of the two comedians in front of the Coronation Hall, a great tribute to them.

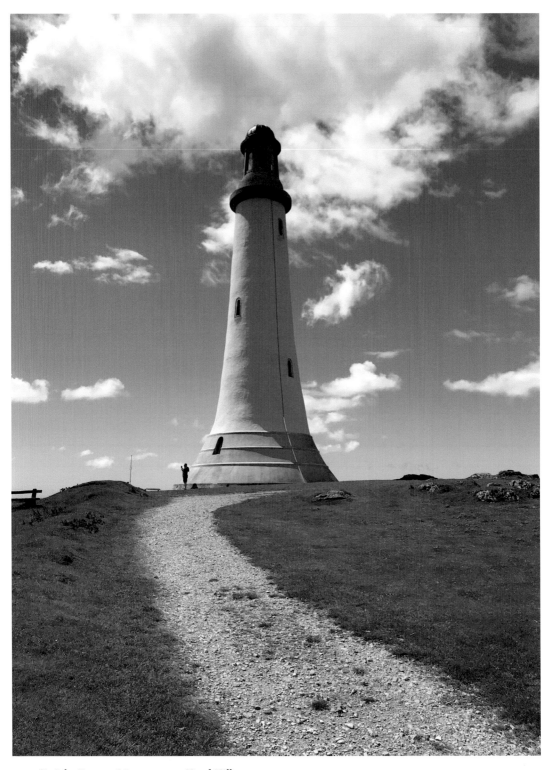

Sir John Barrow Monument at Hoad Hill.

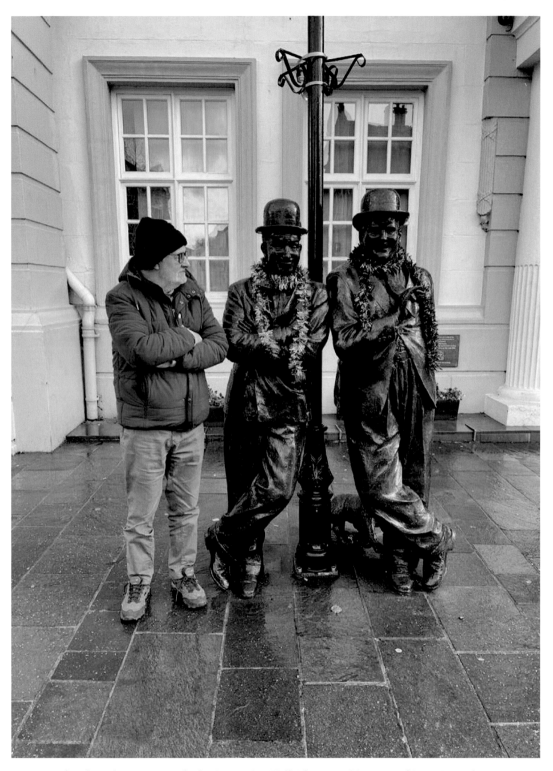

Laurel and Hardy statue outside the Coronation Hall, Ulverston. (Courtesy of Freya Jepson)

5

Early Industrial Development and Growth

Ulverston was an ambitious market town which heralded the later growth of industry and trade. The Furness area had mined iron ore for centuries on a smaller scale, for example there is evidence of iron smelting during the Iron Age at Urswick. It is known that the monks of Furness mined iron ore at Orgrave and Dalton, so it is no surprise that this continued into the early industrial age. Slate too was quarried and exported from the area and in 1774 Ulverston was granted the status of a port. It was soon realised that a canal would be advantageous for trade and a solicitor called William Burnthwaite convened a meeting to consider building one. By 1793 an Act of Parliament was passed to create a canal and raise funds to construct it. The canal was completed in 1796, with wharves, warehouse and a toll office following later in 1797. This enabled the export of iron ore, coal and slate.

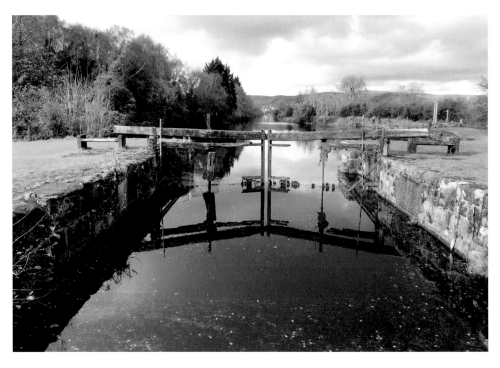

Ulverston Canal.

A remnant of the canal heritage.

Sadly, the canal suffered at the inception of the Furness Railway Company in 1846 and went into rapid decline. Eventually as the port of Barrow grew the Furness Railway Company bought the canal. It continued to be used commercially until the First World War, but by the end of the Second World War it was defunct. It is now a remnant of our industrial heritage and has attractive walks along it and is maintained locally by the council.

Industrialisation changed the status quo in the area once again. Barrow ousted Ulverston as an industrial town and port and Dalton ceded to the now much larger town. It brought in 'off-comers' creating a melting pot of different people from across the country. Industry drew them here and Barrow grew from little more than a hamlet to a bustling town of 40,000 inhabitants within four decades. The natural harbour at Barrowhead was developed and the railway expanded. It began as a rail transport for slate from Kirkby-in-Furness, where the Earl of Burlington (later 7th Duke of Devonshire) exported high-quality slate for buildings across the country.

The mineral speculator Henry Schneider had been assessing the possibility of mining for iron ore in the district. Iron ore mining and processing was one of the industries that the monks of Furness had undertaken. Bloomeries were set up and iron processed, but on a small scale. This activity continued and by the nineteenth century it was suspected that mining could be lucrative once a rich seam was discovered. A prime deposit of rich

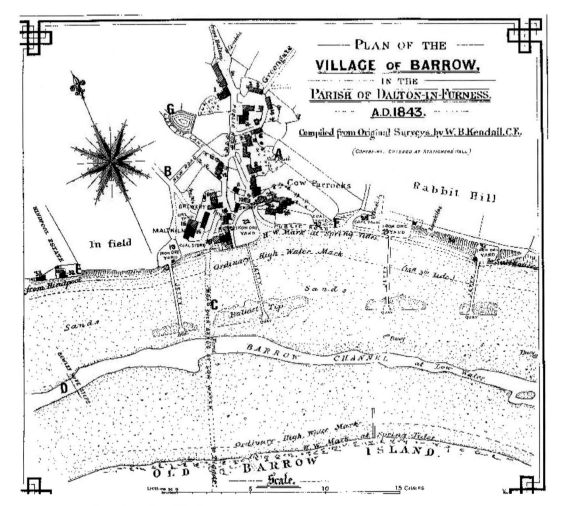

Barrow Village, W. B. Kendall, 1842.

haematite was found at Park mine, and this was the start of a huge industrial surge. Schneider and Robert Hannay established iron works to process the ore, and collaboration with the railway company allowed new lines to be built to transport coking coal from Durham. A Bessemer Steel plant was created in 1865 and this amalgamated with the iron works under Barrow Haematite and Steel Company. This catalysed industry in Barrow and led to other industries developing, such as the boiler works, wagon works, wire works and of course shipbuilding. World trade began and steel rails were exported to far-flung parts of the Empire.

The population rose as work increased and this pressured the town fathers to build homes and facilities needed in a 'modern' town. James Ramsden, a Director of Furness Railway and Devonshire's right-hand man, was heard to say that if he built 1,000 houses, the next week he would need to build 1,000 more. The town was planned with wide straight streets, a far cry from the original three lanes existing from the village. Workers

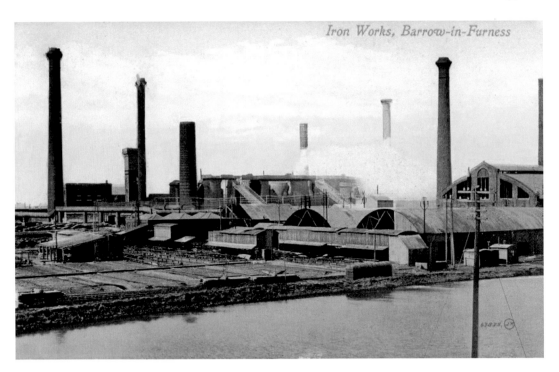

Iron Works, Barrow-in-Furness

Iron and steel works at Barrow.

were provided with homes close to employment, paying rent to their employers in true Victorian paternalistic style. Attention was paid to sanitation and the original temporary huts were eradicated.

People came from across the country: the Irish came for labouring work in the docks and the railway; men from Dudley and Stafford arrived with chain-making and metalwork skills to work in the iron and steel works. Many lived in company houses close to the iron and steel works in Hindpool and Ormsgill, such as Bradford Street. Cornish tin miners came and settled at Roose to work the expanding iron mines, bringing their traditions and religion with them. The mission church was named after the patron saint of Cornwall, St Perran, and the Methodists among them built a chapel at Stonedyke. Terraces of sandstone cottages were built for the miners and their families and endure to this day. The shipyard grew rapidly, and tenements were constructed to house the workers, on Barrow Island. The housing was sanitary and modern, providing decent homes for the families.

Barrow itself is constantly changing, moving from simple terraced houses for workers to new-build homes on the outskirts. The streets were designed in a rectilinear fashion and the Victorian hierarchy was reflected in the types and styles of houses that were built. The employers often provided accommodation for the workers, and this is seen across Barrow. The oldest terraced rows on Salthouse Road (previously Rabbit Hill) were built for workers in the railway in 1848–9. The railway built more as they were needed, in Newland Street, St James Terrace, Burlington Terrace (on the Strand).

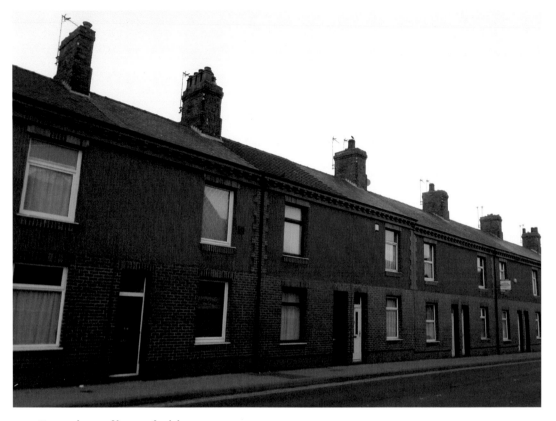

Terraced row of houses for labourers.

Sandstone was the stone of choice in the early years because it was easily available at Ormsgill, for example Paxton Terrace and Church Street and of course the iconic 'blocks' built for Cornish tin miners at Roose.

Other houses sprang up, mostly well designed and with good sanitation, wide streets, and back alleys. The lower the class of resident, the simpler the design of house, for example, houses for labourers were modest, usually with a front door opening onto the street and an outside lavatory in the back yard. These were luxury to some of the people who had left the overcrowding of the towns in Lancashire and the Midlands. The next grade allowed a small walled 'garden' in front, removing the front door away from the street. Some had an extra room downstairs and even a third bedroom. This continued until the houses became grander for the white-collar workers, with front and back gardens. Management were further out of town in 'villas' and then places like Abbotswood or Millwood were for the movers and shakers of Barrow society.

This surge in building created new opportunities for entrepreneurs, such as William Gradwell who became the leading building contractor after 1855, constructing using locally made bricks. He was a councillor and mayor and became well known in the growing town. Gradwell was a joiner and had built a pier at Roa Island in 1847. This was

Roose Cottages, built for iron miners.

the introduction to a successful career. He was contracted to build the first steam Corn Mill in Barrow by a syndicate of businessmen in 1870, as part of diversification of industry in the town. He had his own sawmill and brick works and was perfectly placed to be at the forefront of building the town. The influx of immigrants to the area had outpaced the house building. To alleviate this issue temporary wooden huts had been built on Barrow Island. This proved to be a hive of disease, the two-roomed huts becoming overcrowded and with inadequate sanitation.

The flurry of building began and Gradwell showed he could create housing quickly and efficiently. He built rows of functional terraced cottages which were quickly filled. He was responsible for many other civic buildings, such as the Dock warehouses, Ramsden Square, the Duke of Edinburgh Hotel, St James' Church, North Lonsdale Hospital, Barrow Shipbuilding Works, Crellin Street, Barrow Working Men's Club and Institute, Egerton Buildings, and the main Post Office. Some of these have been demolished, but many still exist. Gradwell was the fifth mayor of Barrow in 1881–2 and served the town as alderman from 1875 until his death in 1885.

The town was unruly due to the number of men coming into the area, and the vast number of beerhouses and pubs springing up. It was said that there was a pub on every corner and in 1871 there were fifty-seven public houses listed in the Barrow Directory,

North Lonsdale Hospital. (Photo Barrow Archives)

this for a population of 17,000! It grew a reputation for being rough like a frontier town and gained the nickname 'the Northern Chicago'. This was gradually mitigated as families joined fathers and husbands and later a Jute Works was built providing work for women, increasing the balance of the female population.

The appearance of this disorderly town, with its smoke and pollution, struck horror into the hearts of the surrounding towns, particularly Ulverston, whose industry had grown in a gentler fashion. There was a spat between the Ulverston press and the *Barrow Herald* over the description of the town. Ulverston asserted that Barrow was controlled by a 'clique' or monopoly, with no free press, growing poverty, unemployment, overcrowding and disease. It further professed that it was 'a sink of monopoly, favouritism and despotism'. This was strongly disputed by the *Barrow Herald*, while admitting that there were some issues which needed addressing but much that was done was for the public good – so in other words, it was a work in progress. They went on to say the criticism was 'unfair, so unscrupulous and so detrimental to the fair reputation of this town of Barrow'. This rivalry or snobbery about Barrow persists even now: both Ulverston and Dalton regard Barrow as the new kid on the block, with less to offer in terms of heritage (Dalton claiming to be the 'ancient capital of Furness'), and gentility and culture appropriated by Ulverston. This is perhaps understandable when you consider the resources and opportunities soaked up by the larger conurbation, but the perceptions are probably not that accurate. Equally, Barrovians see Dalton as a village and Ulverston as 'posh' or elitist. None of these ideas are correct as each of the towns have their own issues, just as they did in the nineteenth century.

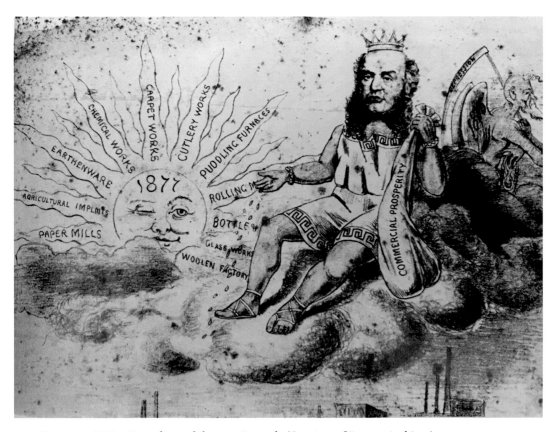

Cartoon satirising Ramsden and the new Borough. (Courtesy of Barrow Archives)

Of course, Ulverston and Dalton were not the only market towns in Furness: right on the edge was Broughton. Broughton is a fascinating place with a recorded history dating back to the eleventh century and before. It was part of the Manor of Hougun under Earl Tostig of Northumbria. The church, St Mary Magdalene, might have had earlier roots in Saxon times, though this building dates much later, from the twelfth century. Broughton was an important market town for livestock and wool. A charter for fairs and a market was granted in the reign of Elizabeth I. This charter is read every 1 August in the market square with all pomp and ceremony.

The town is quaint, with a stunning square, and still boasts stocks for miscreants and fish slabs for the sale of fish from the Duddon. It is surrounded with Georgian buildings and centrally there is an obelisk, erected to commemorate the jubilee of George III in 1810. The wealth of the town is evident in the grand merchant's houses, established in 1760 by John Gilpin Sawrey, Lord of the Manor. He lived at Broughton Towers not far from the square. The town had a market hall, various inns and cobbles, which add to the charm of the place.

It is surrounded by beautiful countryside and although it suffers from traffic running through it, it still retains its rurality and charm. It had some famous admirers, including

Wordsworth and later Cumbrian poet Norman Nicholson, who must have been familiar with the town throughout their lives. They both wrote about the town and immortalised it forever. A person of note who briefly lived there was Branwell Bronte, brother of the Bronte sisters. He had taken up a post as a tutor for the children of Robert Postlethwaite in 1840. It is hard to define what exactly went wrong because the key testimony is from his own hand in letters to friends which was boastful and probably unreliable. He was a 'riotous' drinker and sometime opium eater, which can't have been an appealing attribute for a tutor. He was writing and he met with Hartley Coleridge (Samuel's son) and Thomas De Quincey. He sent Coleridge his translations and poetry, but before this came to anything he had been dismissed by Postlethwaite. He returned to Halifax and from there it was a downward spiral...

Barrow is known for shipbuilding. This grew out of the iron and steel industry. It was a natural progression to develop other industries and shipbuilding became the dominant one. The Duke of Devonshire, with an eye for a bargain, acquired Barrow Island from Mrs Michaelson, the widow of TYP Michaelson. The island is sandwiched between Barrowhead and Walney Island and today it's easy to forget that it is an island at all. Devonshire purchased the island with a view to development in 1862 and he swiftly

Broughton-in-Furness Square. (Courtesy of Nathaniel Jepson)

turned a profit by selling it to the Furness Railway Company (of which he was a director) for another £10,000. The rural island was perfect for the shipyard and dock development, and little is left of the old estate. The Michaelson mansion was demolished and the only hints we have of its past are the stable buildings from the Barrow Island farm and the street name Farm Street.

The shipyard continues to grow but its fortunes have ebbed and flowed over the years. It became the largest employer in the area and outlasted all the other engineering and industrial manufacturers. The bridge which joins the island to Barrowhead leads on to Michaelson Road and the Victorian shipyard sheds or shops line the wide road. There was originally a complex of railway lines connecting various sections of the shipyard and other places like the steelworks. The industrial heart of Barrow is still here, and new government contracts for submarines ensures its continuing growth and expanding workforce. Some of the new buildings dwarf the old Victorian ones but are less attractive to look at.

Devonshire Dock Hall, built in the early 1980s, dominates the Devonshire Dock and was built on the infilled basin. It provided a more secure indoor facility for the construction of the vessels, changing the skyline once more. Since then, even more of these box-like

Children swimming in the docks at Barrow Island. (Courtesy of Janis Carpenter)

structures have appeared and although bright and intrusive and with a purpose to serve, they do little to enhance the town. Expansion is the word of the day and BAE Systems are purchasing some of the derelict shops and buildings in the town centre to create new offices and training establishments. This might not be the most desirable solution for a town in decline, but will surely help to improve the look of it. It's unlikely that the town will ever return to its former glory – progress of a sort I suppose.

In its heyday, the shipyard was controlled by Vickers Armstrong and was a naval construction yard. It was responsible for armaments, warships and submarines. They were a world-class company and the biggest employer in the town. They welcomed dignitaries and naval officers from many countries, including Japan, Argentina, Brazil, Canada, France, India, Russia, the Netherlands and the USA, building vessels for them as well as the UK navy. To do this they built an impressive mansion in their own grounds near to Furness Abbey. Sir Edwin Lutyens designed the building, and it was completed in 1914. The sandstone mansion became the home of the Chairman of Vickers Shipbuilding, Commander Craven. Important guests included Queen Elizabeth the Queen Mother, George V, the Prince of Wales, and the King of Siam. It is still an impressive and beautiful building and is now a hotel. Although it has had extensions by the current owners, they

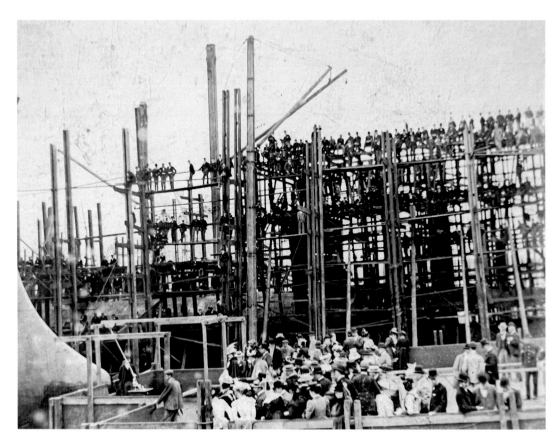

HMS *Vengeance* being constructed in 1899 at Vickers Shipbuilding. (Courtesy of Janis Carpenter)

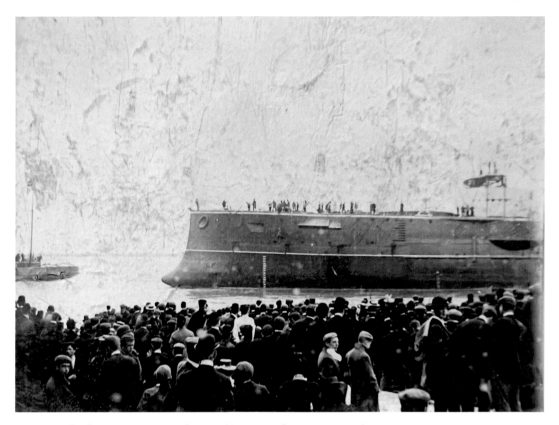

Launch of HMS *Vengeance*, July 1899. (Courtesy of Janis Carpenter)

are at the side and back, thus not destroying the beautiful approach to the entrance. The building is made from local red sandstone, echoing the magnificent ruins of Furness Abbey, and is called Abbey House Hotel.

Barrow was not an obvious place for a 'northern powerhouse' to develop, but the catalyst was the various people who gravitated towards the area and between them set the engines of industry in motion. Each one was important and together they were able to visualise a great future for the area. Without any one of them it might not have become the town it is today.

The Furness Railway was created to enhance the transport of slate and iron ore via the jetties at Barrowhead. Until then carts and horses had been used. The Earl of Burlington, William Cavendish (later the 7th Duke of Devonshire), developed small-scale slate quarrying, which was done by local farmers, by creating larger quarries. The slate was carried to the coast to export via Barrowhead. The quarry was expanded over the years and once the railway was built the transport became more efficient. The second project, which required better transport, was iron ore mining. Initially the ore was exported to be processed and the idea of a railway was very appealing.

These factors were essential in creating the Furness Railway. With the Dukes of Devonshire and Buccleuch as major landowners, it was in their interest to invest in this

Abbey House Hotel, built by Vickers Shipbuilding Co. in 1914.

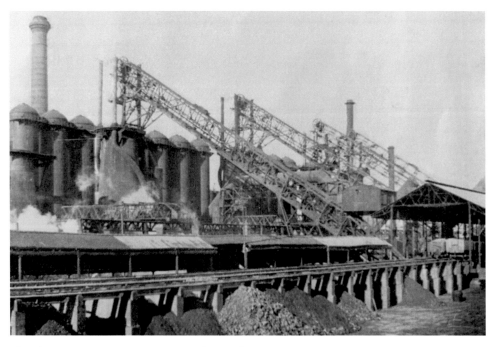

Blast furnaces at Barrow Haematite Steel Co. Ltd.

scheme. They were paid levies from the iron ore mined on their land, so they were keen to stimulate the mining industry. Speculators like Henry Schneider were poised to expand the mines in Furness, and they were keen to make transport more efficient. Devonshire along with his Railway Manager, James Ramsden, had the foresight to create more ambitious plans for the railway and later they expanded in 1857 when they purchased the viaducts built by the Brogdens at the Kent and Levens to connect Furness with the outside world.

The slate quarry at Kirkby expanded and as Barrow grew, it was primed to deliver slate for building and roofing tiles. Burlington quarry is still working, and the slate is exported all over the world. Some of the major civic buildings used Burlington slate, for example St George's Church in Barrow. The slate tips are still visible on Kirkby Moor and the quarry was a significant employer in the Kirkby Moor area. As the quarries grew, the six hamlets around them merged into a village. Kirkby incorporated Soutergate, Beck Side, Wall End, Sandside, Marshside and Chapels. Slate mining was not without its dangers and there are records of miners being killed or injured in rockfalls and explosions. The miners blasted huge blocks of stone, which were broken into smaller pieces with hammers and then removed to cutting sheds to be riven. The mines run for miles across and beneath the moor and rock is removed and cut at the bottom. This is a safer method than earlier times. St Cuthbert's churchyard contains graves of some of those miners who lost their lives at the quarry.

Grave of the Rawlinson family, some of whom were killed in a quarry fall.

Kirkby is an old settlement mentioned in the Domesday Book of 1086, as 'Cherchebei', meaning 'village by the church'. This supports the idea that the church had existed for a long time before the Norman one. St Cuthbert's Church is a mixture of styles and age and its origins are unclear. The original bell tower collapsed in 1657, smashing three of the bells beyond repair. Restoration has continued since then and many windows were replaced in the nineteenth century. It has an extensive churchyard, as mentioned before, and is the centre of the village. The Church of England School was built for the children of the quarry workers in 1877, and the benefactor is recalled in its name, 'Burlington School'. Naturally, it was built using slate from the quarry.

Iron ore mining was prevalent across the Low Furness area and Henry Schneider was one of the major speculators responsible for the expansion of the mines. He arrived in 1839 and at first was unsuccessful, but in 1850 a huge rich seam of haematite was discovered at Park near Askam. He formed Schneider, Hannay & Company in 1859 and began smelting iron locally and developing steel works. The company became Barrow Haematite Steel Company in 1865. Josiah T. Smith was the General Manager and Sir James Ramsden Managing Director, connecting the iron and steel industry with Furness Railway more closely. Hindpool Iron and Steel Works had ten blast

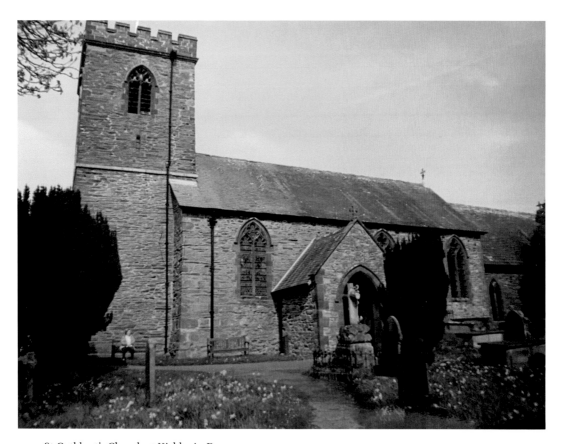

St Cuthbert's Church at Kirkby-in-Furness.

furnaces and eighteen Bessemer converters, continuing until the Second World War, working in concert with the expanding shipyard. The iron ore eventually ran out and the steel industry declined, finally closing in the 1980s. Its importance shouldn't be underestimated as a key contributor to the growth of both the town and its main industry, shipbuilding.

Askam and Ireleth are villages on the outskirts of Barrow. They are coastal and have spectacular views across the Lake District. Ireleth is the older and smaller of the two, probably dating back to the 'Dark Ages' during the Viking settlement in the west coast region. It is understood to have been mentioned in the Domesday Book, but the name is not recognisable and there is dispute as to which name is applicable. The name itself is allegedly Norse in origin and is translated as 'the hill slope of the Irish'. This probably refers to the Norse settlers arriving from Ireland, which we know did happen during this period. Remains were found in the churchyard which could confirm Viking settlement.

A school was endowed in 1608 by Giles Brownrig, originally on Sun Street opposite the vicarage. The plaque in the original school declared: 'Giles Brownrig caused this schol house to be builded the 6th year of King James ano 1608 and gave a yearly salari to the schole maister for ever'.

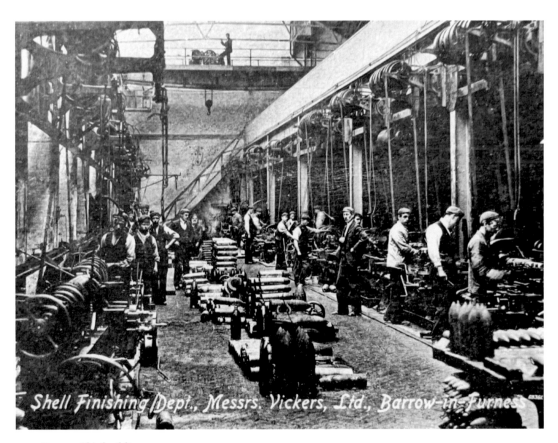

Barrow Shipbuilding.

It is amusing to see the two different spellings for 'school', highlighting that spelling was not consistent or fixed in those days. The school continues to thrive, and the author's mother and uncle attended in the 1930s and 1940s, their names being found in the old logbooks.

St Peter's Church is known as the Iron Church and was dedicated in 1865, replacing the earlier chapel. It was partly built from profits from the iron mines. Originally it was included in Dalton Parish, with permission given to allow worship in the new school for ease of use. In 1860 both Ireleth and Askam applied for their own parish status because of the rapid rise in population. The church at St Peter's was dedicated on the feast day of St Peter, 29 June 1865, but didn't gain approval to become the parish of Ireleth-with-Askam until 1875.

Askam outgrew Ireleth quickly because of the proximity to the mines. The village grew from 1850 onwards on the marshes below Ireleth. Iron deposits found at Park were some of the largest found in the country. Mines sprang up at Mouzell, Roanhead and Dalton, employing hundreds of men. The owners included the Kennedys of Ulverston, Barrow Haematite Steel Company and Millom and Askam Iron Company. It was Barrow in miniature and was closely linked. Four blast furnaces were built in the village, widening the industry, and the railway line linked them to other towns. Housing developed quickly and allotments were provided where families could raise chickens, geese and grow vegetables. Some of these existed until the 1970s. Who doesn't remember being chased by vicious geese up Sandy Lonnin?

Several reminders are still there for us to see, the obvious one being the 'pier'. This edifice is a very primitive structure made entirely from iron slag. It juts into the sea between Askam and Roanhead and is a local landmark. Some of the terraced street bears the names of the iron masters and the industry, like Steel Street, Sharp Street and Crossley Street.

There are numerous ponds, created by the mine workings and sink holes which appear from time to time. Most of the land has been recovered by nature and turned to farmland. The sand dunes and surrounding fields and woods at Sandscale Haws and Roanhead are environmentally important. It's estimated that around a quarter of the UK's natterjack toads breed and live here in the various ponds. The area is designated a place of Special Scientific Interest and is an extremely important and valuable nature reserve and habitat. As well as toads there are frogs and three species of newt, and grey seals sometimes birth their pups on the sandbanks in the Duddon Estuary. It's a highly diverse place with numerous insects dwelling here. Migrant birds fly in for the winter and various rare flora and fauna cover the area. It's managed in part by the National Trust but some of the designated habitat is on or beside private land. Currently, there is a worrying situation which could endanger this unique area. Proposals for holiday campsites are pending, with great opposition from the local people and naturalists. The impact of extra footfall, cars, light pollution, effluent from sewage or septic tanks will put extra pressure on the local resources. Time will only tell what will happen. The area has recovered and improved following industrialisation once, must it do so again?

The iron ore mine royalties at Lindal Moor belonged to Duke of Buccleuch, Lord Muncaster, and the Earl of Derby, all landowners and investors. These mines were big

The iron slag pier at Askam – remains of iron workings. (Courtesy of Peter Burton)

A rare natterjack toad and resident of Sandscale Haws. (Courtesy of Peter Burton)

Sandscale Haws sand dunes. (Courtesy of Peter Burton)

employers and were administered by Harrison, Ainslie, and Co. and the Ulverston Mining Company. As with the slate quarry, mining was a risky business. Many accidents are recorded, and it must have been a very treacherous job. The evidence of these mines lies all around, including spoil heaps and ruined buildings. The danger of mine workings collapsing has been a concern in places, as historical records show.

On 22 September 1892 a large locomotive (Furness Railway locomotive 115) which was shunting wagons on a siding at Lindal suddenly fell into a huge hole that had opened beneath it. An astute and quick-thinking driver, Thomas Postlethwaite, noticed cracks appearing in the ground and shut down the steam. He managed to jump with his fireman off the footplate and onto the ground seconds before the engine fell headlong into the 30-foot hole. The rails snapped and the locomotive was stuck, and only the tender remained above ground. Rescue attempts failed because the hole expanded to 60 feet and then the engine vanished forever. Passenger trains were stopped and the line wrecked. Tons of ballast was dumped into the hole, and it took some time to ensure that the subsidence had ceased. Luckily, there were no injuries, but had the hole opened forty-five minutes later a passenger train to Barrow could have met a terrible fate.

This story was immortalised by Revd W. Awdry in his Thomas the Tank Engine stories – the accident is described in 'Down the Mine, although, in his version the naughty

Thomas ignored a 'Danger' sign and fell down the mine, requiring Gordon to pull him out. Sadly, there was no such happy ending for Locomotive 115.

Another important figure in the industrial development of Barrow was the Duke of Buccleuch's mineral agent Edward Wadham, who arrived in Ulverston in 1851. He installed weighing machines at Dalton-in-Furness railway sidings and Ulverston Canal, unpopular with some because it prevented any manipulation of prices, but for the mine company it assured accuracy.

Wadham asked for permission to undertake other engineering jobs to supplement his salary. He was soon engaged as mineral agent to William Lowther, 2nd Earl of Lonsdale and surveyor for Harrison Ainslie & Co Tramways. These associations were very beneficial for Wadham, and he shared a house at Lindal Mount with William Ainslie and began moving in some illustrious circles. He married Ainslie's sister, Mary, and in 1862 the Duke of Buccleuch built Millwood Manor for him, in a similar way that the Duke of Devonshire built Abbotswood for James Ramsden. Both men were tied closely to their employers and benefactors, yet both were essential components to the creation of the town and its industry. They were both given a private railway siding at the bottom of their grounds, a privilege as Directors of Furness Railway Co. He was well regarded in

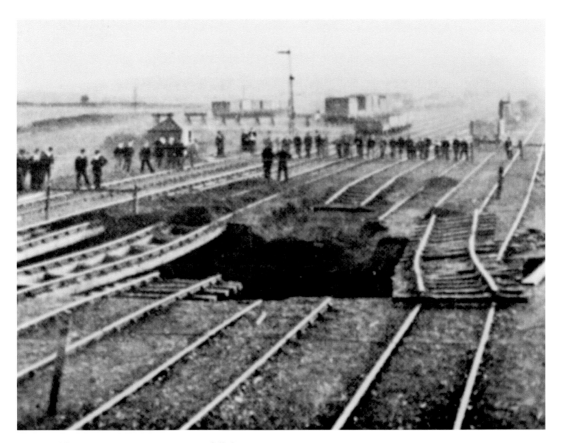

Sinkhole at Lindal where Loco 115 fell down.

engineering circles and was an Associate of the Institute of Civil Engineers and in 1866 became a full member. He was forced to retire in 1872 after being declared unfit to work underground in the mines. His list of achievements and roles withing the industrial community are staggering.

Wadham, like Ramsden, took an interest in the town politics and he served as a councillor from 1867 until 1906, standing as mayor three times. He supported Ainslie as member of parliament for North Lonsdale and later for Sir Charles Cayzer as MP for Barrow. Wadham was a Conservative throughout his career. He left an intriguing set of diaries which have been transcribed and paint a vivid picture of Barrow in its infancy and through its phenomenal growth.

Henry Schneider was another key figure, as has already been mentioned. He was responsible for much of the iron ore mining and became a major investor in the new town. He involved himself with the town politics and was part of the main triumvirate with James Ramsden and the Duke of Devonshire. Schneider became a Director of the Furness Railway Co. He worked in concert with John Hannay and amalgamated his company with Ramsden's, developing the Bessemer steelworks and employing 5,000 people, becoming the largest in the world.

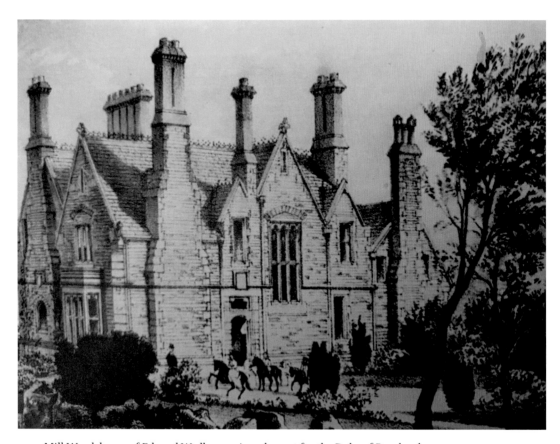

Mill Wood, home of Edward Wadham, mineral agent for the Duke of Buccleuch.

He was elected Liberal MP for Norwich in 1857 and later Lancaster in 1865. This venture ended badly because he had bribed voters and was disqualified. He was mayor of Barrow three times and continued to be heavily involved in the town's development. As with Wadham and Ramsden he had a house in Barrow, at Oak Lea, but his principal residence was Belsfield (now a boutique hotel) above Windermere. From here he took his private yacht, *Esperance*, across the lake to Lakeside where his private railway carriage awaited him and then travelled to Barrow to work. His summer villa, Villa Marina, was at Roa Island overlooking Morecambe Bay and Piel Island. Oak Lea was destroyed by fire, possibly arson by suffragettes in 1913; however, the evidence for this was flimsy, relying on the discovery of a suffragette magazine found in the grounds. His statue was erected in 1891 on Schneider Square near to the original town and the magnificent town hall.

St George's Church.

The final star in this galaxy of entrepreneurs was Sir James Ramsden. He arrived from Bolton aged twenty-three, and was employed as an engineer for the Furness Railway in 1846. His rise was meteoric and some part of this must have been because of his ambitions for the town and his foresight. He rose to Company Secretary quickly and became a director in 1866. Devonshire had faith in his abilities because he appointed him Managing Director of Barrow Haematite Steel Company in the same year. In 1875 he assumed the same position for the Barrow Shipbuilding Company, giving him enormous influence over the industrial landscape. His reward was Abbotswood, built for him above Furness Abbey, which he rented from the company. His knighthood was conferred in 1872 following the incorporation of Barrow as a Borough in 1867 and the rapid expansion of the town's industries.

His political activity included becoming the first mayor, fulfilling the role four more times after this. Despite being encouraged to stand for Parliament in 1885, he declined; his ambitions lay locally rather than nationally. Ramsden used his position to support the town and its growing population, making donations and undertaking projects to benefit them. He was instrumental in arranging civic improvements, including the new cemetery, the creation of a public baths, the working men's club (the House of Lords) and endowments for various schools. He suggested a civic church be built at Rabbit Hill, which the Dukes of Devonshire and Buccleuch funded, and later added a chapel, named after him, with Gothic-style carvings of his wife and himself. St George's Church remains the civic church and there was an inaugural service for the town mayor (until 2022 – after which Borough status was removed, reducing the council to a 'parish' council). He played a key part in the creation of many important buildings in the town and his statue stands in Ramsden Square, opposite the library. He died in 1896 and is buried in a small mausoleum at the top of the cemetery, maintaining an important position in death just as he did in life.

When the town first began it grew rapidly and somewhat chaotically. Workers flooded in from all areas of the country, putting pressure on the meagre resources of the town. Initially housing was primitive and overcrowded, sanitation negligible and the town was unruly, full of men with money to spend and alcohol to be drunk. This situation worsened following cholera outbreaks. A solution had to be found.

The town fathers were aware of this, and they aimed to ensure that the town was the recipient of all modern facilities. Sanitation and provision of health care and education came under this umbrella. The new 66-acre cemetery was created in 1873 for the benefit of the town. The Duke of Devonshire sold the land at a nominal price, and it comprised of part of Sowerby Wood. This relieved pressure on Dalton and Rampside churchyards. Dalton cemetery had opened earlier in 1862, which was where Barrow residents had to bury their dead until then. Thorncliffe cemetery was laid out according to status and religion, reflecting Victorian society. The Anglican burials were at the top with the great and the good occupying the prized plots at the summit of the hill. Further down was an empty plot of land with no grave markers. These were the paupers' graves and those who could not afford memorials, in contrast to the elaborate obelisks, angels and monuments for the wealthy and influential. Behind the CE burials are the nonconformist graves. Many of these are plainer and less ornate in style, wedged between the Anglican and Roman Catholic graves.

Above: Barrow
Town Hall by
W. H. Lynn.
(Courtesy of
Noah Jepson)

Right:
Ramsden's
mausoleum
in Thorncliffe
cemetery.

With its religious statuary the Roman Catholic section is easily recognisable. Huge crosses adorned with Catholic icons the Virgin Mary, Christ, and Sacred Hearts contrast with the simpler stones in the nonconformist section. A separate chapel was built for Catholic funerals but has now become derelict. The original chapel of rest for the other denominations was replaced in the 1960s when a crematorium was built. Of course, the cemetery is now fully inclusive, and a grave can be chosen anywhere.

Left: View from the Anglican section of Barrow cemetery.

Below: Roman Catholic chapel at Thorncliffe cemetery.

There are several dignitaries buried in Barrow, including various mayors and aldermen. Some graves are quite fascinating, including those of music hall artistes, mariners, factory managers and mayors. There are some unusual memorials too, including one to mariner James Gall, who served on the SS *Forfarshire* and who was rescued by Grace Darling. His memorial remembers Grace too and is a replica of the Eddystone Lighthouse in miniature. Others of interest include Private Samuel Wassall who was awarded the Victoria Cross for his action in the Zulu War; John and Joan Waite, killed by a V1 bomb in London a week after marrying; Jack Baggett, a professional footballer; and the Countess of Rossetti Mary Pepi and her husband, Reno, who was a quick-change artist and theatre manager.

Of course, education was a key element in the expansion of the town. A growing population needed to be educated to ensure the future generations were equipped for employment in the town's burgeoning industries. The first school in Barrow at this time was built on Rabbit Hill. Originally there was an engineering college set up by James Ramsden, but in 1849 a school was built for the children of the employees of the Furness Railway Company. It has endured and although modernised in recent years to accommodate more children, it has retained many of its original features.

Education was not universal but had been provided in the villages, in small schools in Urswick, Ireleth, Dalton, Dendron (where Romney was educated), and Ulverston. Barrow village had to wait until 1808 to have a school – based in a cow shed and run by Miss Falshaw, later a Miss Wilkinson, typical of 'dame schools' at the time. Captain James Barrow took over the school in 1815 and these primitive schools continued until the industrialisation brought both money and aspiration.

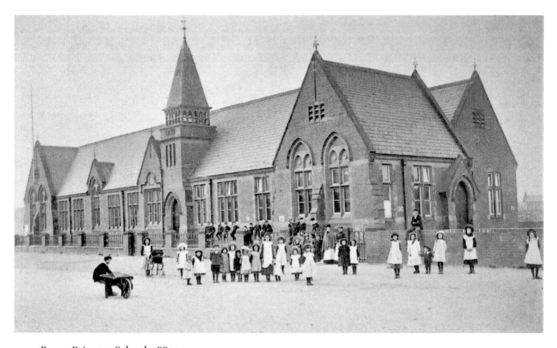

Roose Primary School, 1880s.

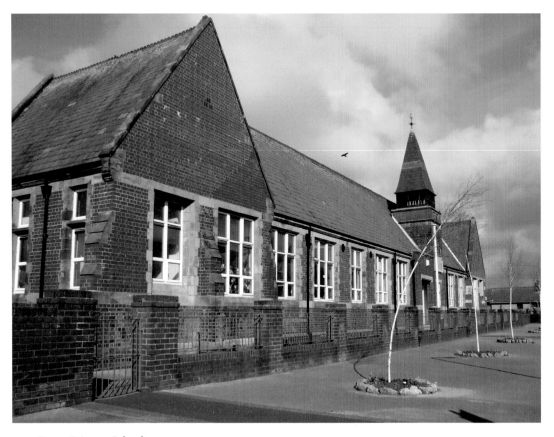

Roose Primary School now.

Schools began to emerge rapidly, often affiliated to the various churches. A rash of private schools and academies sprang up, but it was not until the Education Act of 1870 that state education appeared. Roose School was founded in 1875 on North Row, providing education for the children of the miners. Similarly, other schools appeared, replacing the small temporary ones, like Holker Street, Barrow Island, Cambridge Street, and Hawcoat.

Grammar School education began in 1879 with a Higher-Grade School on Abbey Road – later relocated to Duke Street. Single-sex Grammar Schools didn't emerge until the early 1930s. These were grand buildings with open corridors and quadrangles. The Technical College on Abbey Road was completed in 1903. It was designed by Woodhouse and Willoughby and the main building contractor was W. Gradwell and Co. The 'Tech', as it was known, was the route into industry for skilled workers: many of the town's youth went from there into apprenticeship in the shipyard, prepared for a life of engineering. The building is now an arts and civic centre, renamed the Nan Tait Centre after a local mayor.

The school system has been totally revamped in recent years. The Higher-Grade School, known as Alfred Barrow School, is now a health centre, a brilliant reuse of

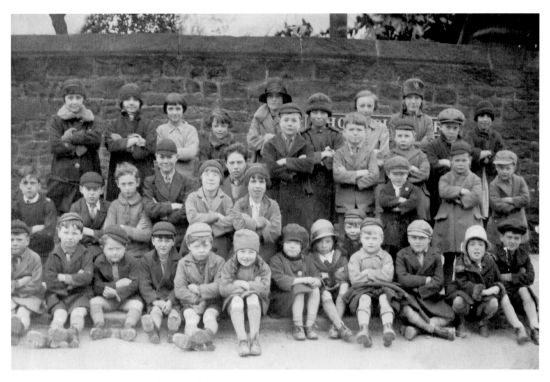

Pupils at Hawcoat School (St Paul's), 1928.

Alfred Barrow Health Centre, previously High School.

a historic building. The Grammar Schools are gone, demolished to make way for housing. The schools were relocated to a site opposite the park and renamed Furness Academy.

St Aloysius RC Secondary and the Convent amalgamated and to become St Bernard's RC School. There is a third high school on Walney Island located at Sandy Gap. There are various primary schools in Barrow, many originating from those in the nineteenth century. Some have disappeared, but others are still around, albeit in different guises.

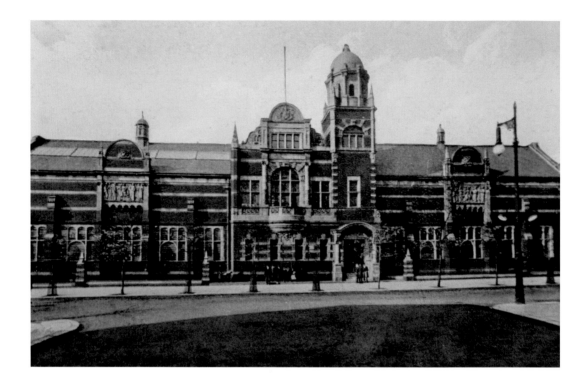

Above: Barrow Technical School.

Left: Barrow Grammar Schools.

Similarly, churches have undergone dramatic changes, mainly due to a reduction in the congregation. There was a rush to build churches in the nineteenth century and to provide denominational choice for the immigrants to the town. Already mentioned is St George's CE Church, which is the civic church, but what of the provision for Roman Catholics? As there was a huge influx of workers from Ireland there needed to be some provision for worship and education. The signature church St Mary's on Duke Street was opened in 1867 and is the main Catholic church in Barrow. The 8th Duke of Devonshire, Spencer Cavendish, donated £6,000 for its construction and it was designed by EW Pugin, the renowned Gothic architect who was responsible for a hundred Roman Catholic churches across the country. It is ornate and impressive and could hold a large congregation of 800 people.

St Mary's
RC Church.

From St Mary's other RC churches grew and with them schools. St Mary's original school was split, creating Holy Family School at Ostley Bank and St Pius X School at Ormsgill. St Patrick's on Barrow Island and Sacred Heart in Lumley Street served the town. Sacred Heart had a school attached which is still in use. In later years the congregation of St Patrick's drifted to St Columba's, a new church on Walney. A school was close by.

Alongside these churches were numerous Anglican and nonconformist churches. St James the Great was designed by EG Paley, built on Blake Street around 1867–69, and was the second Anglican church to be built. It suffered bomb damage during the Second World War but reopened in 1943. It has had funding to restore and conserve the building and restore the bells. It is still a popular place of worship today.

The four temporary wooden and brick apostles' churches – St John's in Barrow Island, St Mark's in the town, St Matthew's in Highfield Road, and St Luke's in Salthouse – opened on 26 September 1878, were built to deliver places of worship for the rapidly growing population. The original architects were Paley and Austin, who were often the architects of choice for many of the civic buildings. These churches were rebuilt at different times and in different styles. St John's is remarkable as it is a concrete construction and is a modern Byzantine design, built in 1934–5. St Mark's is still in its Victorian state and was

St James the Great Church.

extended to become the largest of the four. It is a very active church and does a lot to help those in need. St Matthew's and St Luke's were rebuilt in 1967 and 1964 respectively. Ironically, these two have not survived as churches. St Matthew's was closed for worship in 2015 due to structural issues and St Luke's was demolished in 2012.

Some of the nonconformist churches amalgamated to reduce costs and to move into better buildings. The Emmanuel Congregational and United Reform church was abandoned in 1991 in favour of joining the Methodists on Abbey Road. This was renamed Trinity church and the interior was altered to provide various rooms for worship and parish business. This too has met its demise, and the congregation now gathers at the Baptist Church. Churches are diminishing and some though beautiful and old, are under threat of demolition due to a lack of sustainability. One church that is thriving is Spring Mount Church, which relocated to Salthouse Pavilion, a good use for an old building. Their original new-build church at Spring Mount on Abbey Road has been turned into a multi-faith chapel for funerals attached to George Hall, funeral directors – a happy outcome for both buildings.

Of course, leisure had to be addressed for the new town's people. The beaches were an obvious opportunity for family excursions, some within walking distance. Biggar Bank

St John's Church, Barrow Island.

was immediately popular, with its pebbles, sand and rock pools and the high bank above for promenading. The land was farmland originally, but this was purchased by the town council for use by the public. Gradually the area became a recreational one, with kiosks, pavilions, and bathing huts. It was a great place for fairs and games and eventually a paddling pool and swimming baths were built. People were able to take advantage of good weather and fresh air without spending a lot of money, and it continued to be a place people visited in the summer.

Biggar Bank is still popular, with the Roundhouse café replacing the old kiosk and a play park instead of a pool. There is a good walk along the top of the beach with a clear path and a story trail to listen to. Dog walkers and families frequent the beach enjoying it as previous generations did.

Barrow Public Park was designed by Thomas Mawson in 1900 and land fenced off and allocated. In 1907 it was laid out over 45 acres. It is bounded by Abbey Road, Park Drive, Park Avenue and Greengate Street. It had a lake, greenhouses, a bandstand, and bowling greens. It continued to be developed and in 1921 a cenotaph was dedicated at the top of the hill for the fallen of the First World War. This now has the names of the fallen of other theatres of war including the Second World War.

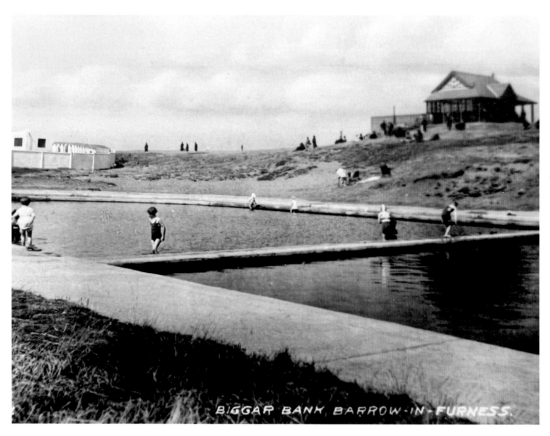

Biggar Bank Paddling Pool.

Victorian fairground in Barrow. (Courtesy of Janis Carpenter)

Barrow Park in 1918.

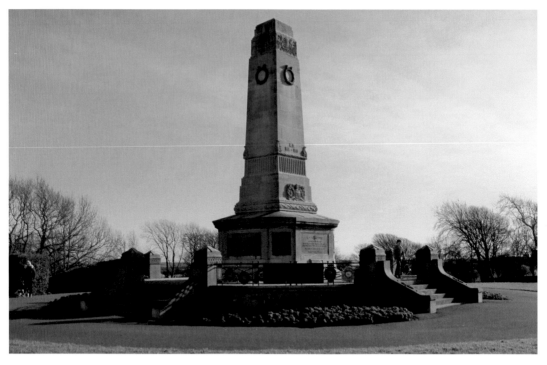

The Cenotaph in Barrow Park, dedicated in 1921.

Pierrot shows were performed at the beach and park at Walney Island. Barrow was a hive of theatres, music halls, and later, cinemas. Touring companies and artists came to Barrow regularly. It must have been a precarious life because William Connor, known as 'Lorenzo', a music hall 'negro delineator', died in his lodgings in 1880. This came after failing to balance twelve chairs on his chin! He seems to have collapsed off stage and was taken home immediately. Sadly, the next day he was found dead. Friends from Manchester paid for his stone.

Cinema proved extremely popular and theatres popped up all over the town. The Ritz (later ABC and then Apollo) was an art deco building with a restaurant, so the picture-goers could have a full 'night out'. Others like the Essoldo, the Roxy and the Regal attracted crowds, including children for matinee shows. Most have gone, after being repurposed or demolished. Some like Salthouse Pavilion became bingo halls. They have all been replaced by a multiplex on the aptly named Hollywood Park.

Her Majesty's Theatre was a serious repertory theatre and many famous actors visited and learnt their craft there, such as Peter Purves (*Blue Peter*), William Simons (*Heartbeat*), David Chant, Steven Berkoff (Octopussy, Rambo, The Krays) and Barry Evans (*Doctor in the House* and *Mind Your Language*). The theatre was demolished in the 1970s. Others like the Coliseum, which had thrilled local children with pantomimes, failed to thrive and again this elegant building bit the dust in 1977. The theatrical replacements were less flamboyant and dramatic, including the Forum, which has had some reputable shows and is the main cultural outlet. Royal Shakespeare Company and Northern Broadsides visited with their classics for a while, but these have not returned for several years sadly.

Above:
A Pierrot
troupe who
performed
at Walney.
(Courtesy
of Barrow
Archives)

Right:
The Palace
Theatre,
Duke Street.
(Courtesy
of Barrow
Archives)

The Regal Theatre. (Courtesy of Barrow Archives)

Semper Sursum: Always Rising

Barrow-in-Furness has lasted because of its unique skill of adapting. It has endured down times but has always picked itself back up. Its future looks rosy, with a huge increase in projects for the defence industry at BAE. This will hopefully breathe new life into the community and town. There is a healthy and growing interest in green technology, with offshore wind farms, solar farms and soon a carbon capture storage facility. Its industrial heritage looks certain to continue for years. Barrow once again is reinventing itself and celebrating its short but rich history.

Other areas in the district continue to change and develop. Dalton is only a small town, but it has a very active community arts and heritage movement. The pride in Dalton is immense and the residents are not afraid to celebrate its attributes. A town trail has been installed and an annual celebration is planned in June for 'Dalton Day'.

Ulverston continues to be a popular place to live, benefiting from numerous building projects and road improvements. As in Dalton, an active arts community is thriving and many creative celebrations are carried on annually, like the Lantern Procession.

We are fortunate to live in a vibrant, creative, innovative and beautiful district.

Ulverston Lantern Procession.

Dalton Christmas Tree Festival.

The Spirit of Barrow.